GHOSTS OF HISTORIC
DELAWARE, OHIO

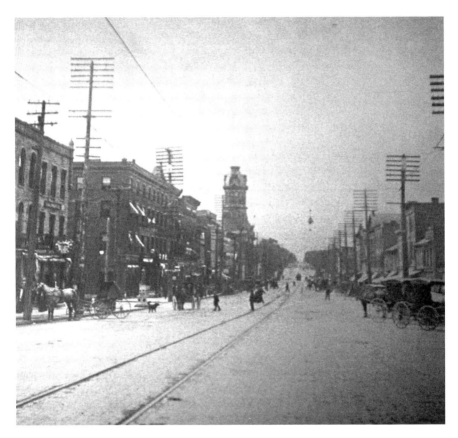

Undated photo of downtown Delaware, Ohio, looking south on Sandusky Street. *Courtesy of the Delaware County Historical Society.*

Contents

16. The Spirits of the Underground Railroad	101
17. A Family's Continuing Dilemma: The Haunting on Eaton Street and Beyond	105
18. Oak Grove Cemetery	109
19. The Haunts of the Ohio Home Cemetery	113
20. The Pennsylvania Avenue Haunting	117
Bibliography	123
About the Author	127

CONTENTS

Acknowledgements 7
Introduction 9

1. The Three Types of Hauntings 11
2. In the Beginning 15
3. The Haunting of the Mansion House 21
4. The Ghostly Encounters in University Hall and Gray Chapel 29
5. The Dead Come Back to Play 39
6. The Murder on Edwards Athletic Field: The Haunting of
 Cynthia Pheil 45
7. The Strand: Delaware's One and Only Haunted Movie Theater 51
8. Delaware's Arts Castle 57
9. Blue Limestone Park 61
10. The East Side Haunting 65
11. The Feline Specter of Hobby Central 67
12. Delaware's Haunted Northwest Neighborhood District 71
13. The Haunted Mansion in the Northwest Neighborhood District 79
14. The Story of John Edwin Robinson: The Pirate of Delaware 89
15. The Ghost of Perkins Observatory 93

GHOSTS OF HISTORIC DELAWARE, OHIO

JOHN B. CIOCHETTY

Published by The History Press
Charleston, SC 29403
www.historypress.net

Copyright © 2010 by John B. Ciochetty
All rights reserved

First published 2010

Manufactured in the United States

ISBN 978.1.60949.063.8

Library of Congress Cataloging-in-Publication Data

Ciochetty, John B.
The ghosts of historic Delaware, Ohio / John B. Ciochetty.
p. cm.
ISBN 978-1-60949-063-8
1. Haunted places--Ohio--Delaware. 2. Ghosts--Ohio--Delaware. I. Title.
BF1472.U6C52 2010
133.109771'535--dc22
2010032460

Notice: The information in this book is true and complete to the best of our knowledge. It is offered without guarantee on the part of the author or The History Press. The author and The History Press disclaim all liability in connection with the use of this book.

All rights reserved. No part of this book may be reproduced or transmitted in any form whatsoever without prior written permission from the publisher except in the case of brief quotations embodied in critical articles and reviews.

ACKNOWLEDGEMENTS

For the past seven years, I have met numerous people willing to contribute stories regarding the supernatural and the unexplained in order for me to continue my writings. It can be said that it has been a wild and exciting adventure. Without their heartfelt support, this book could not be made possible.

Therefore, I want to thank the following people who have made this endeavor a success beyond my wildest dreams:

To Carol Holliger, Emily Haddaway and Catherine Schlicting, university archivists, for allowing me access into the vaults to uncover for myself and others the historical information regarding one of the nation's best educational institutions; former Ohio Wesleyan University president Dr. Mark Huddleston and his wife, Emma Bricker, for giving me encouragement; Kara McVey-Jones, operator of the Strand Theatre, for allowing me to interview her on the haunts of Delaware's one and only haunted movie theater; Kathy Cope and Kevin Greenwood of the Delaware County Cultural Arts Center for giving up a little of their time to sit down with me to discuss the haunting of the Arts Castle; and Thomas Mullenniex, assistant circulation chief of Beeghly Library, including the student library staff, for supplying me with information regarding the haunts of the college library.

A big round of thanks goes to Gary Merrell of the Brown Publishing Corporation and the *Delaware Gazette* for giving me permission to use one of the newspaper's illustrations for this book; the staff and management of the Delaware County Historical Society for their assistance in my research

Acknowledgements

of Delaware, Ohio's rich and romantic past; and Adam Lefevre for his skills in photography and computer savvy that contributed to this book's future success.

To the management and staff of Beehive Books and the OWU Bookstore for giving me the needed support and encouragement to continue on my future endeavors; to Wendy Piper, Julie Blaszak, Andrew "Drew" Peterson and Debra Lamp for allowing me to talk to prospective and current students on the ghostly phenomena occurring at the university; and to the Ohio Wesleyan University Department of Public Safety for putting up with me all of these years.

To the members of the Central Ohio Paranormal Society, Delaware Society for Paranormal Research and Investigations, Manifestation Investigation Service Team in Delaware, Ohio, MAJDA Paranormal Investigations, Misty Dawn Bay, Kenneth Evans from Hilliard, Ohio for supporting my writings and contributing to my work. A big thank you goes to Dr. Marty Ryan for supplying me with newspaper articles regarding the mysteries surrounding Delaware, Ohio, and the university; and to Dr. John Stamey of Coastal Carolina University for his resounding support and advice.

I want to thank Joseph Gartrell, commissioning editor for The History Press, including other staff members from the publishing corporation who have assisted me with advice to many of my questions regarding the preparation of this book. Their degree of professionalism is second to none.

Most of all, I want to thank members of my family who stood by me and supported my efforts.

If I forgot anyone, please let me know and I will thank you in person.

INTRODUCTION

Delaware, Ohio, is geographically in the center of Ohio; it is part of the Columbus metropolitan area. The city is listed on the National Register of Historic Places. It was founded in 1808 and incorporated in 1816. The city originated on a tract of land that is now the east (academic) side of Ohio Wesleyan University. The city and county is named after the Delaware Indian Nation who referred to themselves as the *Lenape* or real men. The Delawares are referred to as the Grandfathers by the Algonquian tribes because it was believed that the Delawares were the oldest of the Algonquian Nation. The city is the birthplace of Rutherford B. Hayes, the nineteenth president of the United States. Rutherford met his wife, Lucy Webb Hayes, the first female graduate of Ohio Wesleyan, in Delaware and proposed marriage by the sulfur spring on the campus grounds. According to *Ohio Magazine*, Delaware was awarded as Best Hometown and the White House designated the city as a Preserve America Community. The city is picturesque; streets lined with trees, properties landscaped to project its beauty and homes restored to their nineteenth-century elegance. Citizens take pride in their city to maintain its Main Street USA image. Families uphold strict work ethics and stick to traditional values and traditions. Delaware, Ohio, is internationally famous for the Little Brown Jug, an event that is part of the Triple Crown in harness racing. Ghost tours are conducted by the Northwest Neighborhood Association every October.

Introduction

People who come from around the United States have heard that the city is one of the most haunted cities in the nation. The spirits walk throughout the city at night.

Ohio Wesleyan University is a private, nonsecular liberal arts institution founded in 1842 by the Methodist church leaders and the citizens of Delaware, Ohio. The university admits students irrespective of religion or race and it highly espouses activism and internationalism. In 2010, the university was one of three educational institutions in the nation to receive the Presidential Award for Excellence and Community Service Award by President Barack Obama as part of the President's Higher Education Community Service Honor Society. According to *U.S. News and World Report*, Ohio Wesleyan is among the top forty colleges in the nation.

Ohio Wesleyan may be the most haunted university in the United States. Ninety-five percent of the university is reported to be haunted. Such accounts of ghostly phenomena have been reported by faculty and staff, students and alumni, and these accounts have been verified by groups using scientific investigation techniques. The groups use state-of-the-art electronic equipment worth thousands of dollars to prove this phenomenon.

Do you believe in ghosts? Some people do and some do not. The skeptics state that we live in the twenty-first century and no one believes in such things. The best answer one can provide is this: You cannot study a ghost under the microscope; you cannot dissect it in a Petri dish; and you cannot analyze it under controlled methods in a laboratory. Science does not have all the answers. A person has to rely upon the element of faith and open up their minds up to the possibility that something is out there which cannot be explained through scientific examination. Just because something cannot be seen or examined doesn't mean that it doesn't exist. Too many persons of integrity and good character, such as some of our United States presidents, scientists, physicians, educators, law enforcement officials and the average citizen, have expressed their beliefs that there is life after death.

Too many people have witnessed such phenomena that cannot be discounted as experiencing delusions or having an active imagination.

The city of Delaware, Ohio, has a rich and romantic history. Its history is closely linked to the ghostly folklore that prevails to this day.

CHAPTER 1
THE THREE TYPES OF HAUNTINGS

What images do you conjure up when you think of ghosts? Do you visualize a vaporous form manifesting itself as you make your way through a graveyard or walk on a road toward some destination? Do you imagine a person coming toward you who is nearly translucent? Or, do you encounter a person you know has passed away, appearing just the way you knew them when they were alive? If you answer "Yes" to any of these questions, then you have just met a ghost.

The first type of haunting resembles playing back a recording of an event. The apparition or spirit you encounter talks or acts the way it did before again and again without any interaction between you and it. This event manifests itself in the present at a certain time, day or night, at a certain place and at a certain date when the episode occurred in the past under the right conditions. This type of haunting is referred to as a residual haunting. The past event produced residue that has been implanted in the area of the incident. Most of the time, such residue is contributed to a situation that spawned strong emotions. There is no element of danger to you.

The second type of haunting involves entities that manifest in partial or full-bodied forms or prefer to remain invisible. These spirits can think for themselves. They may not realize at first that they have separated from their bodies, or they may truly be aware that they have passed from our physical plane of existence and do not attempt to move on due to their uncertainty of what is on the other side after making the crossover to another plane of existence. Nine chances out of ten, there will be interaction between you

and them. In many cases, you may hear disembodied voices, whisperings, footsteps, music, the shattering of glass, knocks and scratching on the walls. And when you investigate these noises, the activity ceases. At the same time, you may detect the odor of perfume or cologne or the scent of cigars or cigarettes in an area where no one smokes. You may feel someone patting you on the head or tapping on your shoulders, something unseen brushing up against you or encounter rooms in a dwelling that are colder than usual (e.g., cold spots in a windowless building when it is ninety-five degrees outside).

There are playful spirits. You may witness doors or windows closing and opening; electrical appliances and lights turning off and on without any apparent reason; furniture moving around the room; and objects disappearing and reappearing in the most unusual places.

The question is why do these spirits act as they do? There may be several reasons for their behavior: They may not want you to stay in an area that they deem to be theirs; they may express displeasure with your actions in a dwelling; or they may try to get your attention so they can communicate with you.

Within this type of haunting, the visual contact phase is the most intriguing. As far as the process goes for the spirit to appear, they have limited abilities. It often takes a living, breathing person to start and complete the process or they may rely upon the physical environment they are in. All people possess an aura and the aura produces natural energy from the body. The spirit is drawn to the aura and feeds upon it, giving the spirit the strength to materialize. The person may observe orbs or flashes of pinpoint lights. They may notice multiple orbs combining together to take the form of a person. That spirit will appear in the way it wants rather than the way you except. In addition to a person's aura, the spirit can draw energy from the light and radiation of the sun or from the electromagnetic fields generated from electrical equipment within the home or building. When it materializes, the entity may appear headless, grotesque, deformed and vaporous, or it may assume the shape of any animal.

The time factor that determines a spirit's stay here on the earth is undetermined because time has no relevance to those in the other spiritual plane. The entity could stay for an hour, a day, a week or for decades and then, it goes away. On many occasions, they may remain dormant for years until a situation triggers an emotional response. As an example, it remains in a house where it lived when they were alive. They may become active when a new resident comes into their home and begins to renovate and make other changes in the house. The spirit comes and harasses the new occupant.

Another scenario involves a new arrival for a young couple. The spirit may be a deceased relative of the couple or of the previous owner who loves children. It has been documented many times that a woman or man has been seen in the nursery watching over and, in some instances, protecting the newly born child.

The third type of haunting is the one initiated when the spirit is asked to interact with the living. This type of encounter is serious and the most dangerous due to the fact that living person is dealing with an entity that is nonhuman. That spirit has never been alive. These spirits existed from the beginning of time and space and are mentioned in the Koran and in the Holy Bible. They often manifest through the use of the Ouija board, witchcraft and through other forms of the black arts. In most cases, when these entities are encountered for the first time, they appear to be friendly and helpful thus disguising their true appearance and nature. Often this is the case when the spirit is contacted through the use of the Ouija board; the person asks the questions and the entity responds with the correct answers. As time goes on, a rapport develops between the living and the nonliving. The person learns to trust the entity until without warning the entity reverses course, causing the person's behavior to be altered in ways leading to a destructive path.

There are two processes that occur in the interaction with demonic and the living: The process begins when the person wants contact with the spirit and uses ways to invite the entity to communicate with them. The demon creates fear and, in the process, destroys the will of its victim through the elements associated with the second type of haunting. This is known as the infestation process. The second process is known as oppression, which involves reducing the person to their lowest point of existence. It begins saturating the five senses of the person with every weapon the spirit can muster: rapping on walls, windows and on furniture; creating voices and whisperings; moving objects through the rooms; drastically changing the temperature of the room; closing and opening windows, doors, drawers and cabinets; and creating grotesque appearances and screams. Then, the process accelerates to an ominous pitch involving gouging, cutting, slapping, kicking, levitating people and objects, creating fires, violently pulling hair and clothing, causing headaches and other illnesses, creating foul odors, showing itself on computer monitors and television screens and loud obscene language. The victim becomes trapped in their environment and they begin to give up. This is the time where the demon starts to possess the person.

In the month of December 2007, Pope Benedict XVI shocked the world when he proclaimed that the Catholic Church needs more exorcists to fight against Satanism. The Holy See came up with a plan in which each bishop would be obligated to have a group of priests in each diocese who were trained in the rites of exorcisms and be on call to execute their duties at a moment's notice.

CHAPTER 2
IN THE BEGINNING

The tract of land on which the main buildings of Ohio Wesleyan University now stand was the center of Indian Life, a scene of picturesque and legendary pioneer happenings, and later, of events of local and some national importance—all these decades before it found its true function as a college site. The metamorphose through which our campus has gone presents a remarkable story. Its earliest central point, the sulfur spring (there were in fact several springs) with its surrounding marsh land served for deer and buffalo as a deer lick, a haunt of coolness and rest; Indians prized it, calling it "Medicine Water"; the spring and a pioneer tavern built nearby played an important part as a rendezvous of soldiers in the War of 1812. The trail from Columbus and Worthington north to Sandusky passed by it. And around spring, tavern, and soldier's camp, themselves surrounded by knoll and vale and thick tangle of shrub, vine and honey locust, pathless, eerie and and romantic, a body of legend and myth grew up. Fiction became strangely mingled with fact.
—Dr. Henry Clyde Hubbert, professor of history at Ohio Wesleyan University

THE FOUNDING OF DELAWARE, OHIO

In the early 1800s, Joseph Barber built his residence at the edge of present-day South Henry Street. He expanded his two-room cabin with a two-level structure, and soon a courtyard, barn, miniature tannery, trading post and a blacksmith shop were built. Joseph expanded his cabin into a tavern that became a focal point for travelers wishing to rest, quench their thirst,

satisfy their appetites and catch up on the news of the day. The trading post became the center of commerce in the area where furs, fruit and spices, horse trading and bartering between Indians and pioneer settlers occurred.

In 1808, Colonel Moses Byxbe and settlers from the state of Massachusetts flocked to the area and established their homesteads near the trading post. The village of Delaware, along the banks of the Olentangy River, began to take shape. The pioneers had a cordial relationship with the Delaware Indian Nation. The Delaware Indians were in the process of moving out and resettling in other parts of Ohio and Indiana in compliance with the Lancaster Treaty of 1744 and the Treaty of Granville of 1814. Before the pioneers made their homes, the Indians established their residences in various parts of the county. Two Indian villages were originally located along the Delaware Run and West William and Elizabeth Streets where Monnett and Austin Halls now stand. Even though the Indians and settlers were on friendly terms, there was a growing concern among the settlers that one day they may become prey to the Indians. An incident soon justified their fears.

Hostility arose when a force of the Wyandot and Delaware Indians came back to the village after conducting a series of skirmishes against unsuspecting settlers in Pennsylvania. They kidnapped a young girl from the Delaware village and traveled with her along the Olentangy River to their camp in Troy Township. A band of pioneers, including the girl's elder brothers, pursued them. At one point during the pursuit, they lost them until they sighted smoke flowing over the treetops of the forest. The posse went in the direction of the smoke until they reached the Indian's campsite. Silently, they crept upon the kidnappers and ran them out of the camp and into the woods, which gave the remaining rescuing party a chance to retrieve the young girl who was never harmed during this entire ordeal.

At the beginning of the War of 1812, the pioneers had great concerns regarding more attacks. To calm their anxieties, blockhouses were built in the county. One of the blockhouses was located at the corner of Sandusky and West William Streets. Delaware's inhabitants did not have to wait for long for additional protection of their homesteads. United States military forces under the command of General Winchester were centered at Urbana, St. Mary's and Fort Defiance, and other military forces for Pennsylvania came down by way of Canton, Wooster and Mansfield. Other reinforcements from the states of Virginia and Kentucky came from Chillicothe and traveled through Delaware County.

In February 1813, General William Henry Harrison, who later became the ninth president of the United States, founded his headquarters in

the house of Colonel Moses Byxbe on Williams Street. In March 1813, Governor Shelby of the Kentucky regiment and his aide, John Crittendon, located his command at the Barber Tavern. His regiment was encamped across from the tavern and just south of the Pioneer Cemetery where Selby Stadium now stands.

Growth of Delaware and the First Haunting

The years of 1812 and 1813 were marled with settlements proceeding north of Williams Street. The village of Delaware was in the center of Ohio and the state legislature, seating in Zanesville, was looking at Columbus and Delaware as possible locations for the new state capital. The prospect of being the central government seat of the state started to attract entrepreneurs and pioneers to establish industry and new settlements in the county.

Barber's Tavern saw its share of expansion as well. During Delaware's early history, the tavern was the scene of many court trials, and the grand and petit jury systems were established to adjudicate the different severity of offenses against the public. The trials were situated among the groves outside the tavern.

The central part of east campus began to flourish. A tannery, distillery and a cocoonery were built to complement the tavern.

The cocoonery was once located where Edwards Gymnasium now stands along the main business section of Sandusky Street. Women with delicate hands were employed to spin threads from silkworms. Due to the British blockades during the war, the threads were transported to the western part of the United States where the silk material was sent to the Orient by ship to be manufactured into the finest clothing of that time. Opposite of the village, on Union Street, was the distillery. Its operation was due to the joint venture of Dr. Reuben Lamb, prominent physician and county recorder, and Rutherford B. Hayes, who later became the nineteenth president of the United States. Across from the distillery was a two-story building where University Hall, the college's administration building, now stands. This structure was constructed in 1808 by Joab Norton as the first tannery in the county of Delaware. The lower half of the tannery was occupied by vats and machinery needed in the manufacture of leather products. Just east of the tannery, a running spring furnished water to the Norton household and to the tannery itself. In 1813, Joab sold the tannery. The new owner passed away a few months after the initial purchase and the

tannery stood abandoned for nearly twenty years. Over time, the foundation of the building began to crumble, which caused the brick and woodworks to separate from each other, leaving huge gaps in the walls and roof. The roof began to leak profusely and the doors and window shutters began to separate from their hinges and swing back and forth due to the wind. The glass in the windows became virtually nonexistent due to acts of vandalism. The areas where the glass should have been were filled in with linen, giving the casual stroller the mistaken belief of seeing apparitions on windy nights. The cracks and crevices throughout the building allowed the wind to whistle and howl loudly, giving many in the village the belief that banshees occupied the tannery. Residents did not venture toward that area in the evening hours. The eeriness of this setting is complementary to an event that occurred on a bitterly cold December evening in 1813.

Two soldiers from General Harrison's regiment stopped by the Lamb-Hayes distillery to partake in some of the newly processed whiskey. During the course of the evening, the two men fell into discord and a bout of fisticuffs ensued. After the altercation, the two men resolved their differences and made their way over the Delaware Run. However, due to the influence of alcohol, their disagreements resumed and another fight began. One of the men produced the fatal blow that sent the other man reeling into a thorny locust tree. As the other soldier went down, a thorn pierced his skull, severing his brain stem. The victor of the fight panicked upon seeing his fallen comrade go into convulsions. He immediately began to realize the possible ramifications of his actions. He picked up his dead companion and went to the tannery where he placed the deceased into one of the vats and covered him up with lye. The soldier returned to the camp claiming not to know where the other soldier went to after leaving the confines of the distillery. He did state later to recollect that the other soldier was contemplating of deserting the unit. Years after this unfortunate event, the dead soldier's spirit returned and news spread throughout the town that the tannery was indeed haunted. The tannery stood unused until it was torn down to make way for a new luxury hotel (Old North or Elliot Hall), once known as the Mansion House. Later the hall was moved up on a small hillside to the center of east campus to make way for the construction of the college's new administration building known as University Hall.

The soldier's spirit made a return visit on May 10, 2001. The spirit materialized in front of a newly hired public safety officer as he was being led on a tour of the administration building. The new employee was never aware of the legends and folklore associated with the university. As the

officer was exiting from the building, he observed a man wearing a military uniform lying on the floor in front of the university's processing center. The soldier was described as wearing a long-sleeved woolen shirt with a pair of black suspenders attached to the upper rim of a pair of brown trousers. The soldier's leather boots were separated along the seams between the soles and the main portion of the boots. The soldier was extending his right hand upward toward the officer as to indicate a summons for help. The apparition faded away as fast as when it first appeared.

The officer reported his findings to his supervisor. The supervisor listened to the officer and the supervisor calmly advised him to always remember what he had just seen. The supervisor never elaborated on the advice he had just given to the new employee.

The soldier returned two days later as the officer arrived at the building to lock it up. When he exited from the patrol vehicle, the soldier stood in front of him. Startled, the officer jumped back and tripped over his own feet and landed spread eagle on the asphalt. The only thing he hurt was his pride. As the officer looked up, the soldier faded away.

Approximately one year later, the officer made inquires as to the history of the campus. By searching the university archives, he discovered information regarding the circumstances of the soldier's death and where he was buried after the altercation. As noted before, the dead soldier had been buried in the bottom of a vat in the tannery. That vat had once been located at the exact spot where the soldier's apparition was first seen in front of the purchasing office on the ground floor of University Hall.

CHAPTER 3
THE HAUNTING OF THE MANSION HOUSE

The Delaware mineral springs attained notoriety in the midwestern part of the United States. The seven springs, along with its sulfurous waters, are found along the Olentangy, a part of the Scioto River, and tributaries that exit into the Gulf of Mexico.

The area surrounding the sulfur springs was settled in 1808. The Delaware Indians had a small village on the location where the pioneers founded the city of Delaware. The Indians referred the springs as Medicine Waters. The location was indeed a favorite for the tribes; not only did the spring water properties provide relief for some ailments, but the springs were a local watering hole for deer and buffalo. The attraction to the water holes became a wonderful opportunity to kill game for the tribal village.

The natural beauty of the landscape and the attraction that the springs had to neighboring regions of central Ohio prompted the building of a luxury hotel later known as the Mansion House.

Preparations of the grounds were essential before the building. The paths to the springs were downtrodden by the buffalo and deer and the grounds had to be leveled. Great care was given not to deface the local Indian burial grounds, and the Delaware Run was cleaned up and widened to give an appearance of an artificial canal.

The hotel was built for the visitors to the springs in 1833. The hotel measured sixty-two by fifty-two feet. It consisted of a basement, four floors and an attic. On top of the attic, the visitor could view the entire countryside including the city down below.

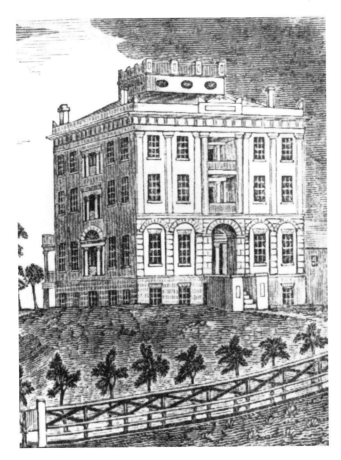

The Mansion House and Hotel, which was converted into Elliott Hall. *Courtesy of the Ohio Wesleyan University Historical Collection.*

The interior was beautifully constructed. The basement had a dining room, a serving bar for the patrons and a huge kitchen with a stone oven. The first floor contained a card room, administrative offices and a ballroom. The guest rooms were on the third and fourth floors. In order to gain access to the living quarters, the guests had to walk on a winding spiral staircase that extended from the basement to the fourth floor.

Often in the evenings, the guests could unwind by sipping on their favorite beverages or to socialize on the balconies of the third and fourth levels of the hotel.

As travelers arrived to the front entrance of the hotel by horse-drawn carriage or wagon, they noticed a structure that was both formal and elegant by design. The Doric façade graced the front giving the hotel a stately appearance.

A short distance from the hotel, numerous cottages and large cold and warm bathhouses were built for patrons to the springs. The bathhouses were

supplied with waters from the seven springs. Hot baths with high sulfurous waters have been recommended by physicians for the preservation of the skin's natural health.

The principal hydrosulfurous spring, located two hundred yards from the hotel, is much cooler and maintains a constant temperature of fifty-three degrees Fahrenheit. It is rated superior than the high sulfurous springs in relation to its medicinal qualities.

In 1838, tests were conducted by medical personnel on the medicinal properties of the waters. The results of the tests concluded that the medicinal value of the springs was high. A visitor from the state of Michigan was helped by the properties of the waters. His health had been deteriorating rapidly. He often complained of suffering from extreme bloating and the inability to consume food. Within the course of two weeks, he began to keep down his food, gain weight, gain strength in his extremities and felt no pain. He fully recovered in two more weeks.

The longevity of the Mansion House was brief due to the declining patronage and the economic Panic of 1837. In 1841, the Mansion House went up for sale and the Reverend Adam Poe of the William Street Methodist Church headed a coalition of Delaware citizens to raise the necessary funds to purchase it. It was the goal of the citizens to establish a college with a town of 898 people. Rev. Poe was a descendent of Indian fighters. He believed in acting upon an idea to its successful conclusion no matter what obstacles stood in his way; his boldness determined his leadership.

The asking price for the hotel was originally $25,000. The offering price was $10,000, and Rev. Poe firmly believed that the citizens could raise the necessary money to purchase it. The college could have easily been established as a Presbyterian college since the Presbyterians had a rock-solid foothold on the town, but the town's people were of a New England persuasion and very open minded to change.

The Northern Ohio Methodist Conference convened in Wooster, Ohio, to debate Rev. Poe's proposal to purchase the old Mansion House to establish a college. It was George Elliott, editor of the *Western Christian Advocate*, whose fiery speech of support for establishing the college gave the conference justification to vote in favor of Rev. Poe's proposal. His speech was the sole factor in changing the name of the building from the Mansion House to Elliott Hall. The college was established in 1842. It took two years before classes were established due to massive renovations to the structure. The hotel began to look like a school. Originally, it was an all men's college. The basement became the registrar's office. The kitchen area was converted into

classrooms. The first floor was used for administrative purposes. The second floor was renovated into offices for the professors and, for a short time, the third and fourth floors were housing for the students. The south annex to the building was also used for classroom instruction.

The all-men's college started to change in 1846 when Lucy Webb was permitted to attend classes in the new hall. Lucy became the wife of Rutherford B. Hayes, the nineteenth president of the United States. In fact, Rutherford proposed marriage to Lucy at the principal spring fountain not too far from Elliott Hall (North Hall).

In time, renovations had taken place to promote stability to the physical health of the building and to establish new fire safety apparatus. In 1891, the entire building was moved, with great difficulty, to a location behind Sturges and Slocum Halls. The new college administrative building now occupies the spot where the old tannery and the Mansion House once stood.

Today, Elliott Hall is the home to the History, Politics and Government, Politics and Public Affairs, Sociology and Anthropology Departments in addition to the Office of Communications.

The fourth level of the building houses the Historian named after the *Historian*, a quarterly journal published by Phi Alpha Theta National

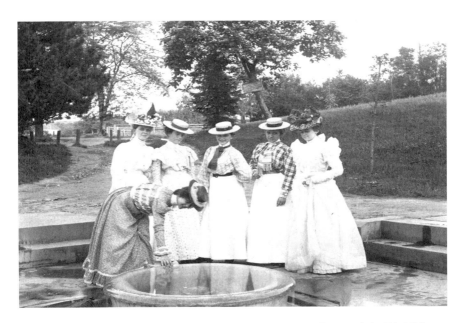

Ladies from Monnett Hall taking a drink from the sulfur spring. *Courtesy of the Ohio Wesleyan University Historical Collection.*

History Honor Society. The journal covers all areas pertaining to the subject of history. The book review section of the Historian has been located at the university since 1993. The Historian is staffed by students under the direction of Dr. Richard Spall. They receive several thousand books per year. Each book is reviewed by the students to see if it would be of interest to those in the field of history and evaluated by a board of regional subeditors.

The Hauntings

It only takes one incident to start an investigation into the paranormal. Early in the morning of July 23, 2004, around 4:00 a.m., I was in the process of leaving the confines of Elliott Hall. I was in the south stairwell walking down the stairs when I heard footsteps above. I looked up, and the door leading from the stairwell to the Historian closed. I ran up the flight of stairs where I stopped short from entering the room. As I stood silently by the door, I could hear a man and a woman talking with music in the background. Silently, I unlocked the door and entered the room. The music and the conversations ceased. A complete search of the room and the other floors began and no one could be found within the building. During the search, there was an overwhelming sense that I was being watched. I tried to shake the feeling, but I couldn't until I left the building. A report was never written about the incident. I explained what happened to my supervisor, Robin Olsen, director of Public Safety. He explained that he understood what I went through because he once lived in a haunted house. I requested that I be allowed to contact one of my friends who was a member of a paranormal investigation group to investigate some of the buildings on the academic (east) side of the campus. Permission was granted.

Kenneth Evans of MAJDA Paranormal Investigations visited Stuyvesant Hall, Gray Chapel–University Hall and Elliott Hall on August 2, 2004. When Ken and I entered Elliott Hall on that day, he signaled to me that a spirit was at the top of the stairs that led to the second floor. As soon as we arrived at the second level, the spirit eluded us. It would not permit Ken to take its picture. We went to Gray Chapel and University Hall. Contact was made with two male juvenile spirits. As Kenneth was standing on the stage in front of the Klaus organ, he took several pictures with his digital camera. I was standing in one of the rows with an EMF meter, which detects electromagnetic fields; the meter went off the scale. In one of the pictures taken, a full-bodied apparition could be seen leaning up against the south

wall of the auditorium of the chapel. Another apparition was seen sitting in one of the upholstered chairs. As we left the chapel, a male's voice loudly rang out calling my name. Both of us turned around suddenly. No one was seen inside the chapel.

At approximately 4:00 a.m., on August 2, 2005, I arrived at Elliott Hall. The second I entered the building, someone wearing heavy shoes or boots could be heard walking on the floor above me. I identified myself and heard what seemed to be several other individuals run across the floor. The next sound I heard was the upper metal bolt to the double doors leading to the balcony being forced down. The doors swung open. I ran up the stairs as fast as I could and went through the doors. No one was on the balcony. It took a considerable amount of effort to secure the doors. The sliding bolt wasn't cooperating. After I locked the doors, all areas of the building were checked. This time I was ready. I went to the university patrol vehicle and retrieved my digital camera that I bought the day before. A second search was conducted with the overwhelming feeling that I was not alone. I was on the third floor and proceeding to exit to the stairwell when I felt that someone was directly behind me. I swung around with the camera and noticed a mist forming around the entrance of one of the conference rooms. A picture was taken. A review of the picture revealed the presence of paranormal activity. A white solid orb could be seen darting in and out from the entrance of the conference room. Further examination of the photo revealed that the orb casted a black shadow on the right side of the door frame. The photo was posted on the MAJDA Paranormal website. Several people in Europe found the photo on the Internet and began to study it. No one came up with an exact conclusion of what it was, and no one was able to debunk its authenticity.

Several rumors persisted repeatedly that a woman was murdered during the time Elliott Hall was a luxury hotel. There is no record of that incident ever occurred. So, in order to investigate that rumor and other paranormal activity occurring in the building, the Central Ohio Paranormal Society from Columbus, Ohio, was requested to visit the campus. The group was founded by Michael Robare, his wife, Gena, and Randy Garrison in 2004. Michael got interested in the paranormal after growing up in a haunted house in Detroit, Michigan, and experienced other paranormal activity in the Columbus, Ohio, area. In 2004, he decided to form his own paranormal investigation group.

On their first visit to the Ohio Wesleyan campus, Michael, Gena and Randy investigated Elliott Hall during the month of March of 2006

during the time students were out of classes during spring break. During their investigation on the second floor, a large fire door opened and closed without warning. This startled the group. On one of the recordings from Gena's digital recorder, a man's voice could be heard exclaiming, "Oh no!" just before the door shut. The group ran out into the stairwell and could not find anyone on the stairs. They were never briefed on the history of the hall and nor were they briefed on some of the paranormal activity that had occurred in the past, but Gena inquired whether a woman ever jumped off of the balcony.

Another investigation was conducted on January 10, 2009, this time by the Delaware Society of Paranormal Research and Investigation. The group was led by Don Arnold, a resident of Delaware, Ohio, and founder of the group. Before they started their investigation, Rachel Shaw, a clairvoyant from Plain City, Ohio, met with a female spirit who was standing in front of the building. The spirit was identified as Laura, a patron of the old luxury hotel. Rachel was able to communicate with Laura. According to

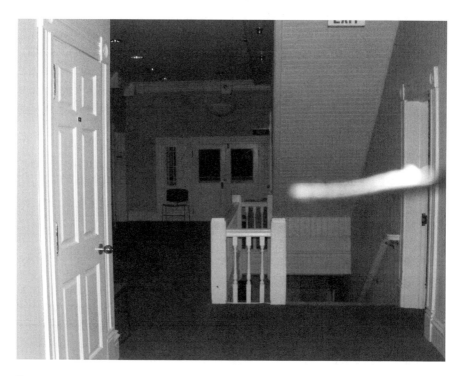

Paranormal activity on the third floor of Elliott Hall. *Courtesy of the author.*

Rachel, Laura would not enter the building due to her fear of another entity identified as Richard, who was standing in the doorway. It became quite evident ten minutes later why Laura had just cause to fear Richard. As soon as the group entered the building, they sensed strong feelings of fear, dread and foreboding, including a feeling that someone was standing before them on the steps leading from the first to the second floor. Everyone in the group turned on their digital recorders to conduct an EVP session.

EVP refers to Electronic Voice Phenomena. EVPs are electronic recordings of paranormal contacts with spirits. Questions are asked by those investigating the paranormal and the answers are given by those in the spirit world. Sometimes, the answers can be heard audibly under the right conditions, but most of time the answers cannot be heard except when the recorders are played back.

A question was raised to the entity standing on the stairs by sixteen-year-old Sara Keeler, one of the members of the group: "are you upset for any reason?" The answer, which was revealed on her recorder, was "Jesus…Yes!" The entity was identified as a male spirit. After the question and answer was given, an unseen hand slapped the ball cap off of the head of Don Arnold, startling him. The group was determined more than ever to continue their investigation. Again, as the investigation progressed into the evening, members of the group had a sense that a woman had fallen from one of the balconies to her death. This time, the opinion was given that a woman did not fall by accident, rather that someone else was responsible for her death. That night, there were more questions than answers.

CHAPTER 4
THE GHOSTLY ENCOUNTERS IN UNIVERSITY HALL AND GRAY CHAPEL

In the 1800s, drastic changes in the infrastructure and academic curriculum were needed if the college was to survive and to compete with most of the academic institutions in the country. Formal education gave way to a new way of thinking and the present physical landscape gave way to new centers of higher learning. The world was changing and it was time to move forward.

The call was made to merge the old classical form of teaching and philosophy with a new liberal curriculum designed to meet the needs of the student.

When James Bashford was the president of the university, the academic curriculum was placed heavily on religious studies, with an emphasis on Greek and Latin languages and mathematics. This curriculum was established from the day the college was founded in 1842. The lessons learned were designed to prepare the student as they ventured into the real world after graduation. The academic structure was so rigid that there was no room for any deviation—that was about to change.

A new era of enlightenment invaded the soul of the young college. The liberalism of thought and philosophy allowed the science of Darwinism to be taught side by side with the classical. It is fascinating to note that most of the science faculty at that time was ordained in the ministry. It would be logical to assume that the faculty would be opposed to this new science, but they assisted the students in merging this new theory called evolution into their Christian curriculum. Some of the faculty were against Darwinism,

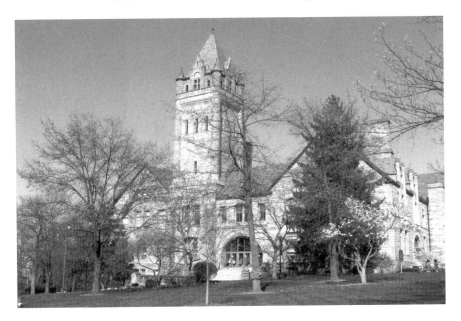

University Hall and Gray Chapel. *Courtesy of the author.*

but accepted and encouraged their students to debate the merits of creationism and evolution. The professors were not favorable toward the study of the sciences, but they realized that the world was changing and if the graduating student was to work in the scientific field, there would be more job opportunities with a greater financial gain. Silently, the faculty hoped and prayed that their students would be guided to a new path of endeavor in areas related to the ministry.

Due these changes, a new optimism for the college called for a revitalization in the school's physical landscape and curriculum. A new wooden gymnasium, named after OWU graduate and United States vice president Charles Fairbanks, was built at the time athletics were being integrated into the academic and recreational curriculums. The new gymnasium was located to the rear of Elliott Hall. A new natural history museum was housed on the third floor of Merrick Hall. The hall housed the Science Department, which offered chemistry, geology, anthropology and other subjects relating to scientific study. Soon, the Physics and Engineering Departments, located in the South Annex of Elliott Hall, were moved to Merrick. Other departments relating to the foreign languages, economics, English, history and theology were introduced to the academic curriculum.

James Bashford wanted to create post-graduate schools of law, medicine and theology to prepare the student for professional occupations. By the end of his administration, his proposals were set aside by the board of trustees.

Other changes in the physical layout of the college began to evolve. Elliott Hall, formally known as the Mansion House, was moved up on a hill behind Slocum and Sturges Halls to make way for the construction of a new college administration building and chapel. Students were diverted to St. Paul's Methodist Church since the Thomson Chapel became unsafe. St. Paul's Methodist Church was located on the site of present-day Beeghly Library.

At that time, the library was located in Sturges Hall, and the need for a new one was due to the college's need to place the increasing number of documents and books in a structure with the correct lighting, ventilating system and an environment for the preservation of rare books.

During this expansionary period, plans were drawn up in 1891 for the building of a commanding structure that would symbolize the strength and prestige of the university.

University Hall

In June of 1893, University Hall and Gray Chapel was finished. University Hall is a massive stone structure, four-stories high with a front spanning 150 feet in height and a width of 160 feet. It was constructed with buff sandstone with a rock-face finish. One of the most distinctive features of the hall is the quadrangular 148-foot tower that ends in an octagonal pyramid, which faces west toward Sandusky Street. The other features are the vertical triangular ends on both sides of the building surrounding the tower, formed by the sides of the roof sloping from the ridges to the overhangs. The style of architecture featured can be best described as the Romanesque or Neoromanesque.

The two entrances, one on the south side facing Slocum Hall and the other with the tower facing west, open to the first floor. Each of the entrances is supported by large Roman stone arches. On the west end, both sides of the arch are carved with the Hebrew words *Boaz* (strength) and *Jachin* (fleetness). On the right side of the arch is the space between the curving of the arch and the rectilinear bounding molding that is adorned with a cross projected outward from its stone background. On the left side, the Holy Bible is projecting outward as well.

The west entrance leads through six double doors into a long corridor in which the south entrance opens into as well. When one enters the corridor or

lobby, they observe hung paintings of all university presidents. Between the doors leading from the lobby to Gray Chapel is a large mirror that was given to the university by Lucy Webb Hayes, after the conclusion of her husband's term as president of the United States. The mirror came from the White House. Flags representing the countries of those students attending the college are seen hanging over the entrance doors on the west side of the hall.

Before the construction of the hall, plans were made to have a ballroom and military drill rooms on the ground floor and recitation rooms and administrative offices on the first floor. The remaining floors were to be used by literary societies. Today, the ground floor is used for many administrative offices that include business affairs, accounting, purchasing, human resources and payroll, student loans, the registrar and the Ohio Wesleyan Junior League. The office of the president and provost is located on the first floor. The remaining floors are used for classroom instruction and for faculty offices.

Students' Pranks

Students used to reside within the 148-foot tower and were employed as caretakers until the end of World War I. They were responsible for locking the doors and keeping the building heated, among their other duties in the area of housekeeping.

In the 1920s, some of the students brought a cow into the tower and tied one of the ropes attached to the bells to its tail. The cow panicked and tried to get loose. The bells were rung like they haven't been rung before for several minutes and rousted up many sleeping residents in the city.

In 2007, a group of students snuck into the hall one evening. They waited until everyone was out of the building. They acquired a large ladder and used it to obtain one of the hanging international flags. They were able to get into the bell tower and one of the students was an expert rock climber. The rock climber scaled the wall and was able to plant the Swiss flag on the top of the pyramid section of the tower. Later, the rock climbing student confessed to the deed before graduation. He was allowed to graduate. Today, the method of climbing to the top of the tower remains a secret.

THE GRAY CHAPEL

The construction of the chapel was funded with a large donation by railroad tycoon David S. Gray, who was a member of the Ohio Wesleyan Board of

Trustees from 1883 to 1921. The chapel was named after his father, Rev. David Gray, one of the pioneer Ohio preachers.

The chapel's auditorium was built in the form of an octagon. The seats were set in seven sections with the aisles extending from the stage to the rear of the room. Above the main floor is the galley circling half of the room. The galley seating was sectioned off in eight halves resting on Corinthian columns rising fifty feet from the aisles. The seats were furnished by the Thomas Kane and Co. from Chicago, Illinois, made from maple and burch. They were stained with a cherry color that promoted a very pleasing atmosphere. At that time, the chapel seated up to twenty-five hundred people, but due to renovations, the seating decreased to twelve hundred.

From the time the university was first established until the mid 1960s, the chapel was used for mandatory religious services. Every student was required to attend. Originally, seventeen services were conducted per week. Attendance was taken and any absence excuses had to be legitimate. As time progressed, the number of services decreased until only one was required for attendance. The services were a requirement for graduation.

What impressed the citizens of Delaware and the academic communities were the chapel organs; the first organ was purchased from New York City

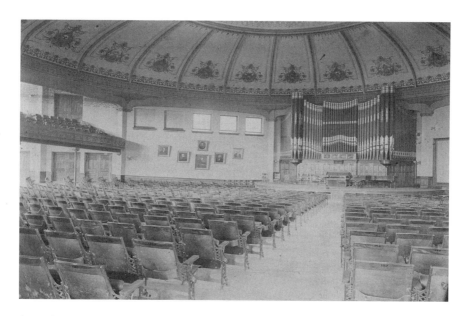

An early photo of the interior of Gray Chapel. *Courtesy of the Ohio Wesleyan University Historical Collection.*

at a cost ranging from $13,000 to $16,000. Later, the second organ installed retained much of the pipe work from the first. It was built by W.W. Kimball of Chicago, Illinois. In January 1980, the organ was replaced by the Rexford Keller Memorial Organ, which was crafted in Bonn, Germany, by the Johannes Kraus Company. It was made of European white oak and contained 4,522 pipes made of a special alloy consisting of tin, mahogany and redwood. The pipes range from one inch to twenty feet in length. The pipe shades are covered with 24-karat gold leafs. The Kraus organ is the largest in the state of Ohio and the third largest in the United States. The cost of the organ was $442,000.

The chapel is used for musical and cultural programs, lectures, high school graduations and other events. Many performers came to the chapel: David Bowie; the Fifth Dimension; the Association; Blood, Sweat and Tears; Jefferson (Starship) Airplane; Dave Brubeck; Bill Nye, the Science Guy; and comedian Demetri Martin, just to name a few. Other celebrities appearing were Louis Armstrong, Carl Sandburg, Eleanor Roosevelt, Shirley Temple Black, tennis great Arthur Ashe, Robert Frost, Leonard Bernstein and U.S. presidents Theodore Roosevelt, Gerald Ford and William McKinley.

The Hauntings

Throughout the decades, rumors have run amuck that University Hall and the Chapel were haunted. One of the hauntings already noted is the visitation of a soldier who had been buried at a location in front of the purchasing office on the ground floor.

On March 12, 2006, the Central Ohio Paranormal Society (COPS) conducted an investigation. During the investigation, cofounder of the group Randy Garrison was in the immediate vicinity where the soldier had been buried. At that point, Randy stopped dead in his tracks. He believed that he heard someone walking behind him. Randy thought that someone was talking at the same time. He was the only investigator in the area. One of the devices Randy had on him was a digital recorder. After the investigation, all evidence—video, digital and analog, and photography—were reviewed. In examining his recordings, a disembodied voice of a man was heard pronouncing the word "Frank."

Is Frank the name of the buried soldier, or is it the name of U.S. senator Frank Bartlett Willis, who passed away in University Hall in 1928?

In 1928, Frank Bartlett Willis aspired to run for the office of the presidency. He was a trusted and beloved statesman in the United States Senate. Frank

had a remarkable record of service as an educator, member of the Ohio House of Representatives, governor of Ohio and as a member of the United States Congress.

On March 30, 1928, thousands of people from the state and throughout the nation descended upon the city of Delaware to hear Frank Willis announce his bid to become the Republican Party's candidate for president of the United States. According to the *Delaware Gazette*, over twenty-five hundred people gathered in Gray Chapel that evening. Before his announcement, the crowd listened to the Buckeye Glee Club singing the campaign song *Farewell*. During the club's rendition, Frank motioned to his congressional aide, Charles Jones, exclaiming, "Jones, I never felt this way before!" As Frank slumped against the wall, he suffered a massive coronary just before he was to address the crowd. He was led into the hallway and collapsed. Some in the crowd brought him to the college president's office where he passed away at 9:09 p.m.

The full-bodied apparition of Willis has been seen in many of the offices in the hall. Reports of the sightings have been uneventful. Some people have described him as being the fatherly type; people who had a hard or bad day at the office may feel a hand on their shoulders as if someone was comforting them. Some could detect the odor of cigar smoke in areas where no one is permitted to smoke, and some have heard a person walking in the hallways when they know that that no one else is in the building.

Other reports of hauntings would center upon a young spirit who is thought to be a teenager who fell over the balcony to his death in the chapel. As noted before, the image of a young male teenager was captured on camera when an investigation was conducted on August 2, 2004, by Kenneth Evans from MAJDA Paranormal Investigations.

Students majoring in music would be assigned to practice on the Kraus organ at certain times in Gray Chapel. On several occasions, OWU graduate and Chicago, Illinois native Justin McCoy would be in the chapel perfecting his skills when he would be interrupted by the knobs of organ stops being pushed in and pulled out by unseen hands. Justin attributed these incidents to the antics caused by the young spirit.

An organ stop is the part of an organ that regulates the pressurized air flow to certain pipes. The stop produces an octave pitch or a combination of sounds. Depending on the type of organ produced, the stops can produce sounds imitating certain musical instruments.

On March 12, 2006, the Central Ohio Paranormal Society investigated the chapel. During the investigation, Larry Copeland, an intuitive medium,

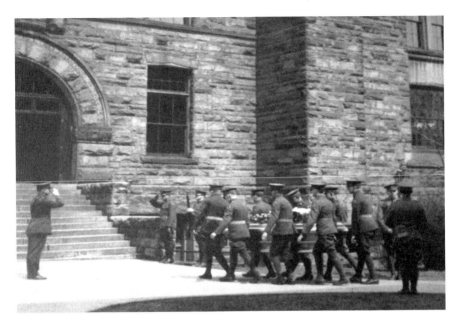

Military funeral of U.S. senator Frank Willis held at Gray Chapel. *Courtesy of the Delaware County Historical Society.*

made direct contact with the young male spirit. Larry learned that young man goes by name of Sean. During the question-and-answer session, Sean was asked who the president of the United States was when he was alive. Sean answered "William McKinley." In addition, Sean identified three more spirits residing in the building: a professor who committed suicide, a spirit with a mean disposition and an elderly woman. Little did anyone realize at that time that two of the male spirits that Sean identified would be encountered in the very near future. The female spirit had a huge impact on the lives of two young boys a few years before.

Delaware, Ohio resident Joanna Keebler came forward with information regarding the female spirit. According to Joanna, she attended a concert with her two sons. It was during the intermission when her sons broke away from her with the goal in mind of exploring the ground floor. At one point, the young men stopped playing when they encountered a woman. The boys had a feeling that the woman was definitely out of place in the way she was dressed and by the way she carried herself. The spirit had a little talk with them pertaining to the correct way to act in public. As the boys started to run back up the stairs to their mother, one of them turned around to notice that the woman had vanished. According to Joanna, she has never had any

more problems with her sons in public ever since. Other Delaware residents recall hearing that, in the 1940s, a woman passed away due to a heart attack in one of the dressing rooms that were once located behind Gray Chapel.

On January 10, 2009, the Delaware Society of Paranormal Research and Investigation (DSPRI) conducted an investigation in the chapel. The first area investigated was the northeast stairwell that leads to the upper balcony. James Shaw of Plain City, Ohio, and one of the public safety officers walked up to the highest level of the stairwell. When they attempted to enter on to the balcony, a loud guttural moaning sound could be heard throughout the stairwell. The atmosphere became oppressive. The moaning was detected on their recording equipment. They checked to see if the sound was generated from outside the building; the area around the building was very quiet at that time of the evening. Their conclusion was that the sound emanated from where they were standing. Incidents such as this have been played over and over. Students and employees of the college have felt an uneasiness when climbing these stairs. The sightings of apparitions watching performances from the stairwell have been reported. On November 7, 2007, such an incident occurred when comedian Demetri Martin took the stage in Gray Chapel.

Demetri Martin is well-known for his appearances on Comedy Central's the *Daily Show with Jon Stewart* and on NBC's *Late Night with Conan O'Brien*. In 2004, Demetri was nominated for an Emmy award for his writings for *Late Night with Conan O'Brien*.

During the performance, security measures were taken to make sure no one had access to the performer's staff room. During that evening of his performance, one of the public safety officers noticed a person looking through the stairwell door window that led to the balcony. The officer converged on the location where the person had been seen and no one could be found. No one could be located in the comedian's staff meeting room as well.

The apparition appeared again at the same location on the evening of January 10, 2009, during an investigation conducted in the chapel by DSPRI. Don Arnold, founder of the group, was on the stage placing a new video cassette into his camera when he was alerted that someone was in the stairwell blocking the light from shining through the slender, rectangular window of the exit door. Don picked up his camera and videotaped the apparition's head and shoulders as it was looking down on him. The members of the group scrambled immediately to the location of the apparition and found no one on the stairwell.

On the evening of January 24, 2009, COPS and DSPRI joined forces in a paranormal investigation of Gray Chapel, University Hall and Edwards

Gymnasium. The evening turned out to be a night to remember. DSPRI cofounder Randy Keeler brought his sixteen-year-old daughter, Hanna, along because she had been developing her skills as an intuitive medium since adolescence. Everyone met together around 8:00 p.m. with thousands of dollars worth of electronic equipment.

The night started off slow until Hanna began the process of contacting Sean. Within five minutes of Hanna's session, K-2 and EMF meter readings began to go off the charts. The atmosphere changed, and spirit activity erupted in most parts of the building. The members turned on more electronic equipment after indications of spirit communication became apparent. During Hanna's session with Sean, one of the investigators recorded Sean's warning to the group: "the bad one is coming…Run!" At that exact moment, a section of the group being led by COPS founder Michael Robare was in the south stairwell. They were about to enter the chapel when Michael felt a hand slam into his chest. He could not move any further. One of the other members received scratches down their back and arms.

On July 9, 1989, a professor of the Modern Foreign Languages Department was found dead in his office at about 6:55 p.m. with a gunshot wound to his head. According to the *Delaware Gazette*, Captain Randy Martz of the Delaware Police Department told reporters that a handgun and a note were found by the body (The professor will be referred to as Dr. J.). Dr. J taught at Ohio Wesleyan for nearly twenty years. His life had touched hundreds of students and fellow colleagues during his time of service. At the time of his death, Dr. J was suffering from a degenerative nerve disease. It has been said by many on campus that his presence is felt in many corridors of the hall. There is a classroom on the second floor that is dedicated to him.

At approximately 3:30 a.m. on July 12, 2008, one of the public safety officers conducted an internal check of University Hall. From the first floor, he could hear someone walking on the floor above him. Silently, he made his way up to the second level and stood motionless for the next two minutes. Due to the condition of the floor boards, it wouldn't be hard to hear anyone walking, no matter how hard they tried to go undetected. The officer heard someone walk behind him. Then, all of a sudden, the sound of two feet slamming onto the wooden floor caused the officer to jump. His keys and flashlight flew out of his hands. He turned around to find no one behind him. The officer exclaimed, "Dr J! Please don't do that again!" The incident occurred in front of Dr. J's former office. It looks like Sean is not the only good-natured and mischievous spirit roaming the building.

CHAPTER 5
THE DEAD COME BACK TO PLAY

"A gym at last, a gym at last; oh by golly, a gym at last!" This was the phrase heard from one end of the city of Delaware to the other in March of 1905. Finally, a facility was being built which would be the largest basketball arena in the state of Ohio.

Ground was broken on March 23, 1905, with the entire student body of Ohio Wesleyan taking the place of horses pulling long ropes at the end of a plow. Dr. William Whitlock, president of the university, guided the students. Several hundred residents of Delaware attended the event. The groundbreaking event was exciting for both the city and the college. The building opened on Washington's birthday, February 22, 1906, and was dedicated in the memory of OWU trustee John Edwards. In June 1903, Edwards and his sons contributed to the funding of the arena by giving $30,000. Due to the great excitement generated by the prospect of building it, donations came in from members of the United States Congress, the Ohio House of Representatives and Senate and from the residents of Delaware, Ohio. It was immediately felt by all that 1906 was a year of growth and great optimism for the city and county.

The arena housed a swimming pool in the basement, which measured fifty feet long and twenty-two feet wide at a depth of four feet at the shallow end and seven feet at the other. Across from the pool were offices used by university staff and students, handball courts, military drill practice rooms and bowling alleys. The second floor was utilized as office spaces for the athletic departments, a locker room containing seven hundred lockers and

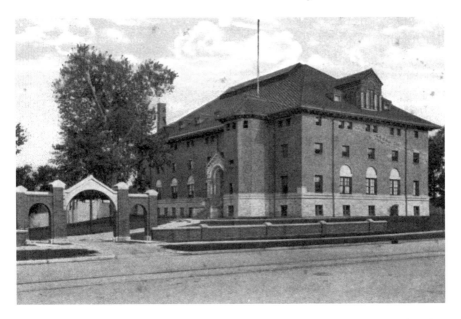

A postcard of Edwards Gymnasium. *Courtesy of the Ohio Wesleyan University Historical Collection.*

bath facilities. The third level is the basketball arena capable of holding three thousand people at any given time. Above the basketball court was a balcony to seat spectators. The balcony was used as a single-lane running track.

Edwards Field was located directly in the rear of the facility. This large wooden stadium was needed for varsity events—football, baseball and track—in addition to being used as a military drilling field. The main reason to construct a new stadium was to play football since the games were held between the Sulphur Spring and the Delaware Run. It became a real hassle to delay a game when the ball went into the run. There had to be a more suitable solution to this problem. A case in point: On the morning of May 3, 1890, Ohio Wesleyan and Ohio State University met for the very first time in a football game. This was the first football game that Ohio State ever played. Both universities did not have a stadium. Ohio State's team arrived in Delaware by horse and wagon. They started the journey at the crack of dawn and did not return to Columbus until late into the evening. Several times, the game had to be delayed when the ball landed into the waters of the Delaware Run. Ohio Wesleyan lost the game by the score of 20–14. Since then, the two colleges have competed against each other several times. Ohio Wesleyan has won only twice during these meetings.

In 1909, Ohio Wesleyan sponsored a post-season basketball tournament consisting of nine high school teams. The event was moved from the Old Armory on West Williams Street to Edwards Gymnasium in 1910. The number of teams participating in the tournament grew to over 120 by the 1920s. The tournament became a state event. In the 1960s, the success of the tournament overwhelmed the university and the last one was held in 1962.

All varsity basketball games ceased in 1977 after the new $2.9 million Branch Rickey and Gordon Field House complex were built. The complex was named after the legendary Branch Rickey, an OWU graduate of 1904 and general manager of the Brooklyn Dodgers. The field house and Branch Rickey is a T-shaped structure with a hyperbolic paraboloid roof. The roof was built in the shape of a saddle. This type of architecture allows the complex to utilize more space than most conventional structures. It's the only one of its kind in the state of Ohio.

During the construction of the complex, Edwards Gymnasium was renovated and the swimming pool was relocated to Pfeiffer Natatorium.

The new gymnasium contained a basketball arena with the seating capacity of twenty-five hundred spectators, six handball and squash courts, four locker

The legendary Branch Rickey (from left) with Coach George Gauthier. *Courtesy of the Ohio Wesleyan University Historical Collection.*

rooms for varsity teams, weight room, a student lounge and numerous offices for the athletic staff. The field house embraces an indoor track and six courts used by tennis, baseball, golf, volleyball and the track and field teams.

Branch Rickey

Branch Rickey was elected to baseball's Hall of Fame in 1967 for breaking the major league's color barrier by signing Jackie Robinson, an African American, to the Brooklyn Dodgers in 1945 and by signing up Roberto Clemente, the first black Hispanic. He was also recognized for restructuring the minor league farm system and for introducing the batting helmet.

Before heading for the major leagues, Branch Rickey (class of 1904) was the head football coach for Ohio Wesleyan and later became the college's athletic director. Before his employment with Ohio Wesleyan, he coached and taught at Allegheny College in Pennsylvania. In 1909, Rickey took a leave of absence from his position as athletic director to obtain a law degree in Chicago. While in the major leagues, Rickey fulfilled several managerial positions: manager of the St. Louis Cardinals, general manager and president of the Brooklyn Dodgers and general manager of the Pittsburgh Pirates.

The Hauntings

I was working late in my office one cold and rainy afternoon. The doors are all locked and no one but me in the Old Gym. As I was pounding away on my typewriter, I could hear someone playing basketball in the gym above me. At first it kind of scared me, but I still went on working…Time went by and I decided to go see who was in the Gym…As I was going up the dark stairs to the second floor, I could hear a basketball bouncing on the floor…But as I pushed the door open, everything got very still-the lights were out-A basketball was rolling down the court, but the player was gone-thus the ghost of Edward's Gym…And I was out of there like a flash… In my car with the doors locked and on my way home.
—*S. Kay Durfey, retired secretary, Ohio Wesleyan University, Department of Athletics*

To say the least, if you would excuse the pun, it appears that Kay was spooked. Other members of the Building and Grounds, Public Safety and

Athletic Departments have, on occasion, heard the sounds of basketball games being played in the old arena when the building is closed for the evening. It's the same old thing when the disturbance occurs and the doors are opened to inquire who is still in the building and it is found that the overhead lights are turned off and no one is on the basketball court.

Tom Watson, housekeeper of Edwards Gym, related a story of an incident that occurred on December 23, 2005. He was sitting on the bleachers in the arena having a bite to eat during his lunch break when he began to hear a basketball being dribbled on the wooden floor and being thrown against the walls on both ends of the court. This went on for about thirty minutes. After his lunch break was over, he left the arena.

There had been accounts of different incidents occurring in the evenings. On June 30, 2007, members of COPS paid a visit to the gymnasium for an investigation. The lights were turned off at that time. During an EVP session, Gena Robare strongly felt that a child was in the arena with her. Gena has had many paranormal experiences in her life. She takes a no-nonsense approach when dealing with the paranormal and is somewhat of a skeptic until proven otherwise. During the session, she was walking up and down the court and called out the question, "Do you want to come out and play?" A faint response in the background could be heard. It sounded like a little girl was responding to Gena's question. A review of the EVP session on her digital recorder revealed a child stating, "I wanna play." There was no child with the group during the entire evening. Two years later, the question of whether or not a spirit child roams the building may have been answered.

In April of 2009, some students were in the arena heavily engaged in a game of basketball when two of the players noticed a little girl walk down the flight of stairs from an area of the old apartment located on the third floor. Since small children are very rarely seen in the athletic building, they opted to investigate. They went up the steps to the old apartment and found no one there. One of the students walked to the ground floor looking for the girl while the other one stayed near the entrance to the arena. After the initial search for the girl produced no results, the students went back to the apartment and found the door closed and locked. As a matter of fact, the only way to lock the door is to use a master key from the outside or to turn the knob and lock the door from the inside. With a key or not, it takes a considerable amount of force to close the door. When one slams it shut, it is heard throughout the southeast portion of the building. The student that stayed behind while the search was conducted saw no one walk up the steps past him and secure the door forcibly.

After World War II, there had been a heavy increase of students and faculty, and the problem arose of where and how to house these two groups. The university had to build and acquire Quonset huts, trailers and other structures. In addition, the college negotiated with the landlords in the area to allow students to rent their properties. The apartment on the top level of the gymnasium was used to house two students. It has been said that the apartment is haunted. Stories have circulated that one of the roommates killed the other over an argument regarding a girl and the other rumor pertained to an accident in which one of the roommates caused his demise. They are only stories and nothing has verified the accounts of the roommate's death.

One evening in April 2010, public safety officer Jay McCain was showing a family member the apartment when he heard someone coming up the steps. He warned the person that it would not very wise to try to scare them. He went to the stairs and the sound of the footsteps ceased and he saw no one on the steps.

During the evening of June 30, 2007, during a paranormal investigation by the COPS team, Sam Clark was walking up the steps to the area near the door of the apartment and something unseen smacked his flashlight out of his hands.

The Hauntings of Pfeiffer Natatorium

One evening, the pool was closed down and students had seen an elderly woman walking around the Olympic sized pool and make her way into the women's dressing room. The student did not recognize her and made an attempt to identify her. During the search, the woman was not found. An encounter two years earlier may shed some light as to the identity of that woman.

In 2003, Ruthann Huston, supervisor of housekeeping for the east campus, came to work early one morning. She was walking down the hallway which separates the pool area from the classrooms when she collided with something unseen. Ruthann believes that she bumped into Mrs. Pfeiffer. Others have speculated that the phantom lady may be one of the former educators. Rick Hawes, Coach of the OWU Swim Team, believes that a woman haunts the natatorium. One evening after a brief swim in the pool, Coach Hawes walked back to his office when he heard a woman humming a tune.

In April of 2010, a journalism student was tagging along with one of the public safety officers. The student was writing a research paper for his class regarding the activities of an officer during his or her work shifts. The student and the officer were walking on the stairs up toward the arena when both of them heard a woman singing. They were the only people in the building that evening.

CHAPTER 6
THE MURDER ON EDWARDS ATHLETIC FIELD
THE HAUNTING OF CYNTHIA PHEIL

The murder of a former OWU coed dominated national news in September 1953. Cynthia Pheil from White Plains, New York, was found in Wyandot County, Ohio, as a victim of murder. Roy R. Schinagle Jr., from Mayfield Heights, Ohio, a sophomore at Ohio Wesleyan University, confessed to the murder of the coed.

Newspapers referred to Cynthia as "the faceless beauty." The identity of the coed was established by the red slippers she wore through a series of tests by a chemist in Columbus, Ohio, who just happened to be her brother.

In 1952, Cynthia and Roy first met a social function at the university. As freshmen, they had been sweethearts and each came from very well-respected families. Their families approved of their relationship, but they did not approve of their plans for an early marriage. Cynthia and Roy wanted to have a child to prevent their parents from stopping the marriage. This loving relationship diverted their attention from their studies, and low grades forced Cynthia out of college. Roy had low grades as well, but he decided to turn his grades around. Through much discipline and devotion to academics, Roy was able to bring his grades up to academic excellence.

According to police accounts, on September 15, 1953, Cynthia traveled to Delaware to visit Roy. She had stayed in a shack located at what was known at that time as the Edwards Athletic Field. She stayed there for two days to prevent anyone from discovering that she was visiting Roy. On the evening of the 16th, the couple had a heated argument prompted when Roy accused Cynthia of seeing another man. She slapped him and Roy became severely

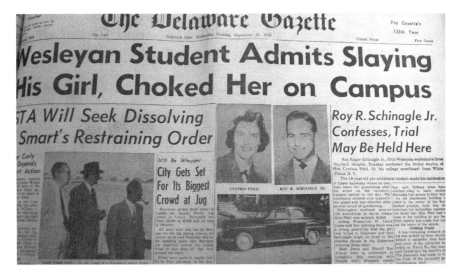

Front page story of the Red Slipper Murder, dated September 23, 1953. *Courtesy of the Delaware Gazette.*

enraged. He strangled her inside the shack and dragged her limp, lifeless body to his 1940 Plymouth Club Coupe. Roy drove the body to Upper Sandusky and dumped her in a wooded area named Rattlesnake Woods, which was owned by the grandmother of Mr. Dennis Wall, who is presently employed as the head foreman for the Ohio Wesleyan Buildings and Grounds Department. Her body was found by a county road worker the next day. Due to the fact that Cynthia's face was disfigured beyond recognition, the only lead investigators had to work with were the red slippers she wore. Law enforcement investigators contacted local shoe sales establishments to attempt to receive information on which manufacturer made the shoes. The authorities were informed that the type of shoes found would be sold in cities such as Columbus, Ohio, and not in small rural areas such as Upper Sandusky. The merchant was able to determine that the shoes were made in a shoe factory located in Columbus. When the police contacted the manufacturer, records indicated that the particular line of shoes worn by Cynthia was shipped to White Plains, New York, Cynthia's hometown. Since she had been missing for two weeks, the police were able to put the pieces together. Investigative leads as to the identity of the killer grew cold until police found out that Cynthia had a boyfriend at the university. Law enforcement officials from Upper Sandusky came to the Ohio Wesleyan campus on September 22. They were able to locate Roy and pull him out of class. Later in Wyandot County, Roy confessed to the killing.

According to the *Delaware Gazette*, Wyandot County sheriff Dean McCallister, Delaware County sheriff Earl Fravel and Roy Schinagle went back to Delaware to search for the murder weapon. A steel rod was found underneath the Winter Street bridge that was determined to be the weapon used to beat Cynthia. It was also determined that Roy beat her in such a way so no one would be able to recognize her.

Schinagle was incarcerated in Wyandot County during the convening of a grand jury, which determined that Roy was responsible for Cynthia's death. He was charged with first-degree murder. Through a plea agreement, Roy pleaded guilty to second-degree murder. He was sentenced to life imprisonment with the possibility of parole in ten years if he exhibited good behavior. Roy served ten years and a day in the Ohio Penitentiary and was released on December 3, 1963. He presently resides in Strongsville, Ohio. He is in his middle 70s.

Is Cynthia Still With Us?

As noted before, Cynthia stayed in a shack in the south end of campus, which was referred to as the Edwards Athletic Field. The murder occurred in direct proximity of what are now the offices of the Buildings and Grounds Department and the Littick Baseball Field on Henry Street.

Some students have mentioned strange events occurring at the baseball field but failed to elaborate on the events they witnessed.

Delaware, Ohio residents have reported seeing a young lady wearing clothing indicative of those worn in the 1950s walking on Henry Street at night. When they turn around after driving past her, they find no one walking on the side of the road. Often, the witnesses report that the young lady does not have facial features. Another incident reported in the mid-1960s revolved around a gentleman driving on South Henry Street as he was about to drive near the Selby Athletic Field. He saw Cynthia walking toward the area of the stadium. He stopped his vehicle and offered to drive her to her destination. She got into his vehicle and as he started north on Henry Street, they began a conversation. Cynthia stared out the window and did not look at the driver during the entire time. She told the gentleman that she wanted to be let off at Hayes Street. As soon as the driver stopped his vehicle, he turned to her and noticed that she was not inside his automobile. He got out of his car and walked around it. He walked up the road and did not find her.

None dare walk that stretch of road at night; screams of anguish and horror have clearly been heard.

Cynthia's spirit is not at rest even though her killer was incarcerated for his crime. But, is his punishment enough? Or is Cynthia waiting for him to arrive on the other side where Roy would meet his final judgment?

The Old Pioneer Cemetery and the Haunting of the Selby Football Stadium

The path that Cynthia walks is the site of the Pioneer Cemetery, which existed in the early 1800s. According to university and county records, the cemetery ran the full length of the present-day Selby Football Stadium including the stadium parking lot and along Henry Street to the tennis courts. The first pioneers of Delaware, Ohio, and soldiers who fought in the War of 1812—under the command of General William Henry Harrison—were buried there. As the city of Delaware developed, the graves were exhumed and placed in area cemeteries. According to Brent Carson, director of the Delaware County Historical Society, not all of the bodies had been exhumed.

In 1929, excavation began on the site of the cemetery for the construction of the Selby Stadium. Bodies were unearthed during the process, but due to inaccurate records the city did not know how many more bodies were still in the direct vicinity. Construction workers were startled to find the skeletal remains contained in an elaborate burial site. It was later determined that the remains were of a Native American.

According to an article appearing in the *Transcript*, dated October 26, 2006, the skull was taken from the grave and mounted on a wooden plaque. The plaque was given to the winner of the gridiron games between Ohio Wesleyan and Wittenberg College. This tradition ended in 1989 when the U.S. Bureau of Indian Affairs expressed outrage toward the destruction of the Native American's sacred remains. The skull was reburied with its remains in the Johnny Appleseed Corporate Center in Minerva Park. In 2003, the tradition was resurrected by alumni members from both colleges. A skull was obtained through a medical warehouse and painted in such a way to appear aged. It was mounted on a plaque.

Selby Stadium has a seating capacity of over nine thousand. At the time it was built in 1929, its press box was one of the largest in Ohio, second to Ohio Stadium at Ohio State University. It was designed by the former athletic director and OWU's Hall of Fame coach George Gauthier. The stadium

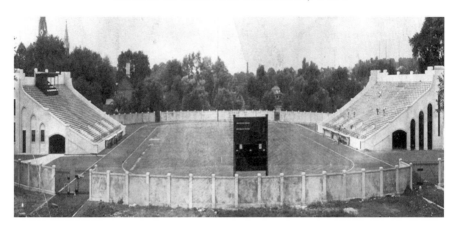

Selby Stadium, the site of the former Pioneer and War Cemetery. *Courtesy of the Ohio Wesleyan University Historical Collection.*

was named after George Selby, who served on the Ohio Wesleyan's board of trustees for twenty-four years. Selby's four sons donated over $100,000 for the construction of the stadium.

The most recent haunting occurred near the end of the spring semester. The wife of public safety officer Russell Logsdon was driving toward the stadium when she noticed a man dressed in a suit indicative of the 1920s standing at the very edge of the roof facing Henry Street. She believed that the man was about to jump off the top of the stadium to his death. She was about to call her husband when the man dematerialized into a vaporous form.

Chapter 7
THE STRAND
DELAWARE'S ONE AND ONLY HAUNTED MOVIE THEATER

The Strand Theatre, dubbed the House Beautiful, opened its doors during the evening of Monday, April 10, 1916. The Strand was built for live performances and film presentations. Performers' dressing rooms led from the rear of the stage to stairs leading to the second floor. The stage was decorated with the finest array of curtains. The theater had a balcony on the second level with a projection booth to the rear.

Patrons entered the theater through an acorn-leafed archway from East Winter Street to find an auditorium basked in a soft green tint illuminated by a series of gaslights that gave the atmosphere a feel of luxury and comfort. The people felt secure in their upholstered seats with decorative iron supports and in the knowledge that the house was fireproofed through and through. The ventilation system silently forced fresh air into the theater without the hint of a breeze. Sixteen hundred people attended the first showing.

The Strand's first owner was Henry Beiberson, whose goal was to bring the best of entertainment to the people of Delaware provided that the shows were clean, entertaining and educational. Beiberson was described as a gentleman in every sense of the word. To the people who knew him, they held hope for much success for him in years to come. Don't let his gentle nature fool you for one moment. Beiberson used his height and stature to physically remove college students who became disruptive. In the 1920s, when silent films came to being, the Wurlitzer Company built a pipe organ for the theater. When talkies arrived, the organ was used as a showpiece. It was sold in 1961. The theater has seen its share of owners

The haunted Strand Theatre in Historic Downtown Delaware. *Courtesy of the author.*

over time, and, in 1971, the Strand was bought by George Johnson and his wife, Cynthia.

George Johnson came to the United States when he was a teenager. It was his dream, after gaining American citizenship, to buy and operate a movie theater. As a teenager, he worked in a theater for his uncle in the state of Wisconsin. When the Strand was purchased, George and Cynthia began immediately on renovating its interior by restoring the floors with new carpeting, seats and the decorative pipes. The sound system was replaced with a new Dolby stereo sound system. The screen, which covered the entire stage, was given a new coat of silver oxide to permit the showing of 3-D movies. George built a second theater to play the best films.

In 1993, Delaware was shocked and dismayed to learn that the Johnsons were closing the theater in January 1994. George Johnson was tired of attempting to show first-rate movies. The Johnsons were able to show films from Universal Pictures. The other eight film distributors would supply the Johnsons with hardly anything at all. In 1990, this situation did not go unnoticed. State representative Joan Laurence brought a bill before the Ohio House of Representatives that would compel distributors to accept bids from theatres. A subcommittee was formed to deal with this problem, but nothing came from it.

In 1994, Jerry Amato and his wife, Cathy, took over the Strand in February. They worked long and tedious hours trying to provide the public with the right kind of movies. Because the Strand is owned locally, Hollywood preferred to work mainly with big distributing corporations. The Amatos had to work with what they had. They introduced independent films to the public that included foreign films and those that bear artistic quality. In a college town, the audience for these types of films was huge.

Kara McVey-Jones worked for the Amatos while attending Buckeye Valley High. She loved the theater and learned everything there was to operate it. In 2000, Kara took over the reins from the Amatos. She worked as much as eighty hours or more a week to maintain it. She wanted the Strand to be a community theater. Kara was not the only one with the same goal in mind. Ohio Wesleyan University president Dr. Thomas Courtice had approached the Amatos a year before Kara took it over with a proposition of buying it. Dr. Courtice requested that Kara present the same proposal to the board of trustees of the university. The idea was to assist in helping Delaware grow. The university faculty wanted to use the theater as a part of their curriculum. Kara worked closely with the Office of Student Involvement to implement late-night film showings for the student body during finals week and to maintain the Ohio Wesleyan Community Film Series.

INTERVIEW WITH KARA MCVEY-JONES

June 4, 2005

Most theaters are haunted and Kara Jones has experienced ghosts since 1986 since she first worked at the Strand. The ghost she has encountered is referred to as the Vaudeville Ghost, which has always been behind the stage in the area of the dressing rooms. According to Kara, when the employees would walk upstairs to turn on and off the air conditioner every evening, the hairs on the back of their necks would stand up and they would run out. No one went by themselves, but even when they would pair up they would run out. Mr. Hayes, the HVAC technician who provides maintenance for the theater, has felt the hairs on the back of his neck stand up. He has worked in the building for thirty-five years.

That is the only ghost Kara has encountered since the first day she worked at the theatre. In 1987, her cousin, Rodney, usually worked in the projection room. Rodney passed away in a house fire and immediately after his death

Kara felt his presence in booth number two. When people would encounter him, he would manifest into an orb of light. Kara stated that Rodney is very friendly, and theater patrons would receive a good feeling when they see him.

When Kara took over the Strand in 2002, the employees would tell her about more encounters with the ghosts in the theater. She encountered the Vaudeville Ghost when she was stationed behind the concession stand talking to a friend on the phone and turned around to see him standing in the vestibule staring at her. Kara described him as an apparition with his arms crossed in front of his chest, a beard and dressed—not like a janitor or like a manager—but as a caretaker of the theater. Kara left the building immediately with no questions asked. She admitted that he is a force not to be messed with.

Kara has consulted with a paranormal investigator who conducted one of the annual ghost walks in the city; the investigator informed her that when renovations are conducted, it allows ghosts to become active. When the Amatos purchased the theater, they conducted the renovations in the box office and concession stand areas. Kara has since made peace with the ghost.

In April of 2003, Ohio Wesleyan University sponsored their annual Slice of Life program for prospective students. One of the events planned was a Vaudeville show presenting *The Babbling Bishops* and *The Outsiders*. After the show concluded, the Vaudeville ghost was nowhere to be seen. Kara had always wanted drawings of the stage and she did not possess any. After the performance, Kara and the staff found a box that was six feet in length and about eight inches deep up against the wall behind the stage. The box had never been seen before. In examining the contents of the box, it appeared to have been packed in the 1960s according to the information found inside it. Ironically, a stage drawing in a frame was located inside the box. Now, the drawing is located on a wall behind booth number one. Kara always says that the Vaudeville Ghost gave the drawing to her as a gift for bringing back the Vaudeville acts.

In the past, some of the staff had direct encounters with the Vaudeville Ghost. Matthew "Matt" Rosenthal, an OWU student employed at the Strand, had encountered Rodney but never informed Kara of this incident. Matt sensed that Rodney was a peaceful and helpful spirit, but when he was in booth number two, he met the Vaudeville Ghost face to face and ran out of the building. Matt came back the next day and found the broom and dust pan twenty yards apart from each other when he rapidly left the theatre. The last encounter Matt had was when he witnessed a spirit of a man floating toward him between booths two and three. The ghost was only seen from the waist up.

The third ghost identified by Kara is Cynthia Johnson, one of the previous owners of the Strand. Cynthia passed away of breast cancer in 1998 while in Greece. Even though Cynthia was buried in Greece, she is inside the building. Kara said that Cynthia was a prankster in life. Cynthia also put on Avon's Skin-So-Soft bath lotion. When Kara was in the projection booth alone in the building, she could smell the odor of the lotion as well as cigarette smoke. There have been bizarre breakages in the past that the employees always contributed to Cynthia.

In the balcony theater, there is a haunted chair. Patrons would sit in the very first chair to their left as they climbed the steps to the balcony. Once they sit down, they would be tapped on the shoulder. There is a concrete wall behind them. It's Kara's favorite seat. Kara had only one of her patrons report that they had encountered a ghost; the encounters are always occurring after the theater has closed for the evening.

One morning, Kara came to work and, once inside, she began to hear what sounded like someone smacking the concrete floor and arm rests to the seats. Believing that an intruder was inside, she called the Delaware Police Department. The police officers believed Kara's suspicions that an intruder was in the theater and began a search of the premises. No one was inside. Sometimes, she would bring her dog, Riley, with her at work. Usually, dogs can sense the paranormal. If Riley becomes nervous, Kara will work rapidly to finish her closing details.

CHAPTER 8
DELAWARE'S ARTS CASTLE

Businessman William Little moved to Delaware, Ohio, to improve upon his quarry business with his partner, horticulturist George W. Campbell. William Little owned a twelve-acre blue limestone quarry located off West William Street. Little sold the quarry to Campbell. George Campbell slaved over the operation to make his business one of the most productive in the nation. It is reported that thousands of tons of limestone were excavated out of the two quarries per year. In 1846, Campbell married Little's daughter, Elizabeth. Little presented the young couple a home that presently stands at West Winter Street. The home was built in the Anglo-Norman style with its arched windows, arched doorways and round tower located in front of the house. The house became to be known as Delaware's Castle. The home was built out of limestone.

George Campbell was known in the world as a horticulturist. He grew a vineyard on his property and from years of developing new strains of vegetation he came up with the Delaware grape. The Delaware grape is a refined derivative of the *Vitus labrusca* grape species, commonly known as the fox grape. The Delaware grape is pinkish in color, sweet in taste and has a skin tender in nature. Its skin can be easily separated from the fruit. It does not possess the bitter taste associated with the fox grape that makes it quite popular in producing dry, sweet and sparkling wines throughout the world. The wines produced from the grape are pink or white in color.

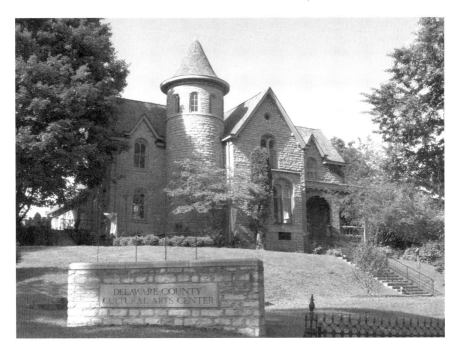

The Delaware County Cultural Arts Center, or Arts Castle. *Courtesy of the author.*

George Campbell traveled in China to conduct his research in horticulture and came back to Delaware with a ginkgo tree that is still blooming today.

Following the death of George Campbell in 1898, the home was purchased by Dr. Aaron Lyon. Dr. Lyon renovated the home and gave it to Ohio Wesleyan University. The home was known as Lyon Art Hall, which was the university's Fine Arts Department. The cost to maintain the home was too much for the university to bear and the castle was sold to Delaware County, where it was renamed the Delaware County Arts Cultural Center or the Arts Castle. Today, the castle has a gift shop, several administrative offices and nine studios within it.

Around Halloween, the Northwest Neighborhood Association of Delaware, Ohio, and the Arts Castle hold their annual ghost walk tours of the city. People throughout the state of Ohio and from other states attend it each year. You see, like the city of Delaware, the Arts Castle, along with the Blue Limestone Park, is haunted.

Interview at the Arts Castle

April 29, 2010

People who walk past the Arts Castle have caught glimpses of an elderly woman clothed in Victorian era attire either standing at the front entrance of the home or standing in one of the windows when the building was closed.

I had the chance of interviewing Kathy Cope, director of administrative services, and Kevin Greenwood, director of the Arts Castle, regarding the mysterious and the unexplained at the castle.

Every autumn, the castle sponsors a fundraiser known as the Arts Castle Affair where the works of dozens of artists are displayed and sold. Part of the process of the sale is that every item is carefully inventoried and documented of when it is received, the description of the item and the name of the owner or artist. Then, it is returned back to the artist for sale. On one particular evening, there were two women in the castle counting money, and it was discovered that an earring in a set of jewelry was missing. A complete search was conducted and the earring was not found. On the second floor, the women were working with the deposits for that day and there was a series of rapping on one of the windows. There was no tree near the window on the east side of the building. The women became puzzled by what was causing the rapping. They believed that the sounds may have been coming from the floor below. The rapping continued for some time, and the women decided to go downstairs to investigate. They realized all of the doors in the center were locked and no one was in the building. They went back upstairs and the rapping had ceased. The missing earring was found in the midst of the counted money. One of the women began to panic a little and wanted to leave the building. They finished their work in a hurry to leave.

Another incident revolved around one of the female instructors one evening when the instructor heard piano music playing. She was the only person in the building. At first, she believed that one of the staff had forgotten to turn off the radio in the basement and then dismissed that assumption because she then believed that the music was coming from across the street at Ohio Wesleyan's Music Department (Sanborn Hall). The next day, the instructor mentioned the details of the incident to one of the faculty members. The university professor explained that the music was not coming from the hall since it was closed for a period of time. It was determined that the music was not a recording due to the music's clarity.

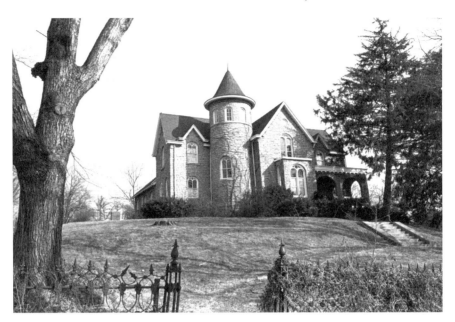

The former home of George Campbell and Lyon Art Center. *Courtesy of the Ohio Wesleyan University Historical Collection.*

Kathy Cope has worked many evenings by herself in the Castle and has never felt threatened or uneasy during the twenty-two years she has worked there. She recalled one unsettling incident involving a painter who had been hired as part of the renovating crew. He was standing on the staircase between the first and second floors when all of a sudden a blast of cold air rushed past him from the second floor. The second floor was checked and no windows were found open.

A lot of unexplained events have been contributed to Elizabeth Campbell even though no one has ever seen her apparition. Nothing which had occurred is characterized to be malicious. Elizabeth has always been referred to as being a spirit who is playful or helpful.

Chapter 9
BLUE LIMESTONE PARK

A Place Where Mysterious Sightings and Phantoms Never Cease

As one leaves from the confines of the Arts Castle and walks to John Street, they gain sight of the entrance to Blue Limestone Park and George Campbell's limestone quarries. Blue Limestone Park has been the main favorite for Delaware families and college students alike; whether it's picnicking under the shelters, playing ball on the diamonds, investigating the mysteries of the old abandoned tunnel and limestone quarries or simply strolling throughout the park. Also, it is a favorite for young couples planning for that special rendezvous under the light of the full moon. The park derives its name from two of the limestone quarries that are separated by a two-hundred-foot-high embankment where the railroad tracks rest.

The park has spawned legends. It has been rumored that the park is the home of many spirits in addition to being an area associated with cult activity and murders. Other rumors have circulated around Delaware that, in the 1920s and 1930s, the Columbus Mafia has used the quarries as a dumping ground for those who had crossed them.

Behind the main quarry is an elaborately built tunnel that allows water from the Delaware Run to flow through. There has been much talk over the years that the tunnel is the site of cult ritual activity and evidence of such has been left behind to substantiate these claims. Visitors to the tunnel report disembodied voices coming out of nowhere as they stand still near its center.

Water-filled quarry at Blue Limestone Park. *Courtesy of the author.*

Others claim that they believe they are being watched by someone unseen, and some have sworn they have seen their breath as the temperature drops significantly, even though the temperature outside the tunnel may be in the upper nineties.

In the summer of 2004, a local merchant went to the tunnel late in the evening with one of his employees. He was a rational person and did not believe in the legends that are associated with the park. He and his associate sat down in the center of the tunnel to talk and as they looked out toward the opening from which they came, they caught sight of a young lady walking back and forth in the moonlight. They watched her for about one minute. Suddenly, she stopped and looked their way. She started walking toward them and they noticed that her feet did not touch the rocks and water below her. As she was about to make contact with them, she dissipated into a fine mist. They did not hesitate to leave the tunnel and not look back.

The two stone quarries are no longer in use. They became useless during the late 1920s, and for decades water has accumulated in areas left over from the dredging of limestone, thus forming natural ponds. Attempts have been made to determine how deep the ponds are but all have been unsuccessful thus far. The railroad that rests upon the embankment was once Delaware's

The Haunted Tunnel at Blue Limestone Park. *Courtesy of the author.*

second railway. One of the stories that persist to this day is the news of an accident in 1927 that caused the deaths of passengers riding the train as it spilled into the quarries. While the story is currently unsubstantiated, it is still one of the most popular of all Delaware legends. But is it a legend or is it a fact, as most residents living near the park suggest? Well, in the summer of 1995 around midnight, a group of college students decided to walk the road to the shelter overlooking the main quarry. As they looked down from the shelter, they could see glowing shapes coming out from the watery depths of the quarry. The apparitions floated above the water and traveled to various parts of the park. Some of the couples who parked near the edge of the quarry witnessed this awesome sight. Sounds of screams and the squealing of tires destroyed the serenity of the night.

CHAPTER 10
THE EAST SIDE HAUNTING

At the age of fifteen, Eleanor Hensley moved into a spacious apartment on the east side of Delaware, Ohio. She liked her new home and planned to make new friends and start school right away. Eleanor was vivacious, intelligent and very outgoing. Once school started, she had no problems winning over her teachers and fellow classmates. Things were looking up for her. She made straight As in all of her classes, and she was constantly being hounded by students to be involved in school plays and in junior varsity sports. Eleanor was basically a normal and bright teenager, but there was one aspect of her life that was kept secret from everyone except her mother—Eleanor can see spirits! From the time when she was six years of age, Eleanor was aware of her gift and had many encounters with the supernatural. For the next six years, her new home would provide more encounters.

At the age of sixteen, Eleanor started to sense that something unseen was aware of her presence. She felt as if she was being watched and that every room was full of negativity. At the age of eighteen, her life started to turn itself upside down.

On one particular evening, Eleanor prepared to retire for the evening. Her mother was sound asleep in the next room. She finished her homework and decided to lie down to sleep. The lights were turned out and as soon as Eleanor's head hit the pillow a horrible chill surged throughout her entire body. She shrugged it off. As soon as she closed her eyes, her body reverted to a state of instant paralysis and something started to apply pressure on her

chest. According to Eleanor, she could not breathe. When she attempted to get off of the bed, the pressure got worse. Eleanor looked upward and noticed the silhouette of a person hovering over her bed. Her room was dark and the silhouette was darker than pitch black. At one point, Eleanor gained enough strength to say the Lord's Prayer and the shadow person vanished into thin air.

A few months later, she moved her bedroom to the rear of the apartment. One evening, as she sat on the bed, she felt the walls close in on her. She felt it very difficult to breathe. From her room she could look into the adjacent room where she observed tall dark shadows moving back and forth several times. She attempted to escape from her room, but the shadows blocked her attempts. Eleanor began to hear heavy breathing fill the room in addition to the whisperings made by several entities. She could not understand what they were saying let alone the language they were speaking. To say the least, Eleanor could not sleep that night. The next evening, she was lying on her bed when all of a sudden a hand grabbed her right ankle. Moments later, she was pulled off of the bed and thrown into the wall. Eleanor hit the wall feet first. The violent action propelled her upper body forward, causing her face to hit the wall. After she recovered from this episode, she could feel a stinging sensation on the ankle where was grabbed. Upon close examination, she found several fingerprint marks on the side of her ankle. From that moment forward, she began to see more shadow people.

These encounters with the demonic took a toll on Eleanor. The entities almost reduced her to her lowest ebb. She started to suffer severe bouts of depression. Thoughts of committing suicide came to her now and then. Eleanor began to involve herself with the occult and ceremonial rituals and went so far as to paint a pentagram on her bedroom wall. Finally, she could not take it anymore. After five long years of torment, she moved out of the home.

After leaving the apartment, she was able to make it on her own. Her life improved dramatically. At the present time, Eleanor has a new home, a new job, a baby and a loving partner. She continued with her education and completed it.

To this day, she is still sensitive to the spirit world. She still sees spirits and shadow people, but they do not come near her. Eleanor's faith in God strengthens her.

(Eleanor's true name changed upon request.)

CHAPTER 11
THE FELINE SPECTER OF HOBBY CENTRAL

You would logically assume that a ghost or spirit is a person who has passed over to the other side after death. But what about our pets? It is comforting to know that our furry friends, who have provided our homes with joy and who have given us their unconditional love for all of these years, do have souls and—at one time or another—come back to us. Such is the case with Benny, a Siamese cat who resided within the confines of Hobby Central since 1995.

Hobby Central is a retail establishment that provides hobby enthusiasts with everything associated with coin collecting, wood sculpting kits, plastic modeling, comic book collecting, baseball, football and basketball card collecting, trains, War Hammer gaming and so on. It is a popular store for both the young and old alike. It's located in the Troy Road Shopping Center off Central Avenue.

Hobby Central was started on September 17, 1992, by Jamie Long and Craig Semon. The store was first located at 77 North Sandusky Street, across from the Moose Lodge. The establishment was relocated to the Troy Road Shopping Center on July 5, 1994. The reason for the move was to increase the size of the store and be located in an area with better parking. It was situated beside Delaware Antiques Limited, which was owned and operated by Patricia "Pat" Greene. Pat owned two Siamese cats named Mecaff and Ming. The cats did not live with Pat at her residence but in her store. The cats were between the ages of seven and nine at the time. In 1995, Pat retired and gave the cats to Jamie and Craig. Later, Mecaff was renamed Benny and

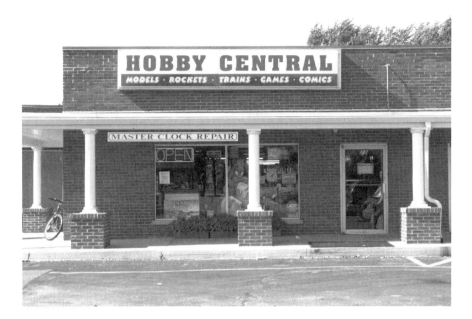

Haunted Hobby Central. *Courtesy of the author.*

Ming was renamed Bobby. Both cats craved attention. Every time a customer would enter the store, both of them would compete to see who would be petted first. Bobby was the most aggressive in getting the attention he wanted, but soon the patron's attention would shift to Benny due to his distinctive sound he made when he meowed. When Bobby passed away, Benny had the store all to himself. It was at this time when he started to come out of his shell and claim ownership of the store. Over the years, Benny's health began to deteriorate. In 2009, at the age of twenty-one, Benny was put down. A lot of people were saddened over his passing. But this cat had ten lives.

In the evening, some of the adults and teenagers would assemble in the back rooms to play War Hammer games. It was two weeks after Benny's passing that the gamers noticed the cat's return. Benny's reflection would be seen on the glass doors of cabinets in the back rooms. Benny's apparition was once observed sitting on one of the chairs underneath the tables. In one incident, someone saw Benny standing on top of one of the tables and a box had fallen to the floor for no apparent reason. According to Jamie, he believed at first it was Bobby that had the habit of knocking things over but Jamie learned otherwise soon after the incident had occurred. Even when Benny could not be seen, his presence would be clearly known when he was heard giving that certain distinctive noise when he meowed.

In May of 2009, Jamie Long was preparing for Comic Book Day. This was the day when customers would receive one free comic book. Jamie was hard at work putting comics on the table in an area closest to the store's entrance when he stopped to talk with one of the customers. Benny was seen jumping off the top of the table and landing between Jamie and the customer. The customer, who knew about the reports of the haunting, became ecstatic.

Jamie stated that he has never been able to see Benny in the store, but that may change in time.

CHAPTER 12
DELAWARE'S HAUNTED NORTHWEST NEIGHBORHOOD DISTRICT

Delaware is geographically in the center of the state of Ohio. It is part of the Columbus metropolitan area and the city is listed in the National Register of Historic Places. The northwest neighborhood area is quite picturesque with quiet streets lined with trees and neatly trimmed vegetation. The residents of the neighborhood have restored their homes to maintain their nineteenth-century elegance. They do not advertise the fact that many homes in the area have been affected by paranormal phenomena. Over time, the residents have accepted to live with those who have passed on to the other side.

Spirits walk the streets from the late evening to the early hours of the morning. Under the right set of circumstances and conditions, they can be seen even riding in two- and four-wheeled vehicles.

At approximately 6:00 a.m., on Saturday, November 7, 2009, one of the residents was startled to see a coach and its driver proceed down the wrong way on North Franklin Street. The coach was described as having a low body with one seat facing forward, which can hold one or two people, and a raised driver's seat supported by an iron frame. The coach was pulled by two horses. The coachman was described as a bearded gentleman wearing a top hat and a heavy overcoat that was double-breasted with wide lapels. He was holding a whip in his right hand and the reins in his left. As soon as the coach and its driver drove past the Ashbury Methodist Church, they vanished without a trace. This incident can be classified as a residual haunting.

In the fall of 2005, Cindy Kelsey (name changed upon request) was completing her morning run in the neighborhood on North Washington Street when she had the feeling that someone was following her. Cindy turned around to notice piles of leaves being kicked up in the air. She looked closely and could not see any animal or person causing the leaves to be kicked upward. The circumstances did not feel right. Suddenly, Cindy heard her name being called out. She was the only person on the street at the time. Cindy made a mad dash back to her home one block away.

Spirits walk the streets at night. Sometimes they take a route from Lincoln Avenue, going south on North Franklin Street to West Winter Street and proceed past the Arts Castle where they arrive at Monnett Gardens, which is situated between Sanborn Hall and Austin Manor on Elizabeth Street. Monnett Gardens is on the former site of Monnett Hall, the Ohio Wesleyan Female College. The college building was razed in 1978.

Monnett Hall was built in 1853 and was made out of brick on a limestone foundation. It was patterned in the Tudor Gothic or Italian villa-style of architecture with an outstanding tower and turret, arched entrances and various porches. Some parts of the building rose from three to four levels.

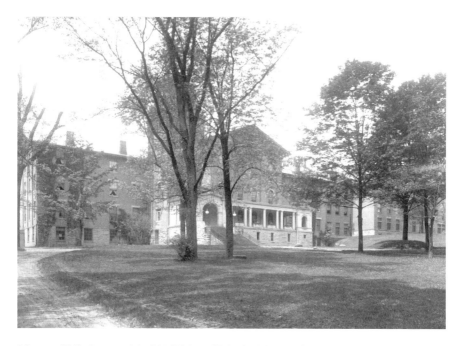

Monnett Hall. *Courtesy of the Ohio Wesleyan University Historical Collection.*

The hall contained a chapel, various rooms for recitals and literary societies, a massive cafeteria that held up to 250 women, elevator, library, rooms for the students and a home for the college president. Before Monnett Hall was built, the original Delaware Female College was located where Beeghly Library now stands.

Mary Monnett, a graduate of the Delaware Female College, donated $10,000 for the new Monnett Hall. Due to the passing of her mother, Mary inherited $100,000. In the nineteenth century, young single women did not live alone, and Rev. Gurley took her into his home and managed her estate. Rev. Gurley orchestrated the marriage between Mary and John Bain, a businessman. Mary and John moved to the state of New York after the wedding. When they came back to Ohio, they found that Rev. Gurley squandered most of Mary's estate in risky business deals. At that time, Mary's mental health was deteriorating. She was committed to a mental institution until her death on July 30, 1885.

In 1968, Monnett Hall was closed down. Even though the building stood vacant for ten years, activity never ceased. Residents living nearby and students in Sanborn Hall witnessed lights inside the building even when the electricity had been turned off. Figures of women could be seen looking out the windows and apparitions could be seen floating from the upper floors to the ground below. Even when Monnett Hall was open for the students, ghostly activity occurred.

One of the most interesting accounts of paranormal activity was the accounts of a ghost in the 1870s. For several nights, the women of the hall witnessed a female apparition, dressed in a black high-necked gown, standing in the hallway on the third floor between the elevator and the library. The incident prompted the formation of a paranormal investigation group founded by the women residing in the hall. In the 1960s, one of the female residents of Austin (Manor) Hall saw the same apparition and drew a sketch of what she saw that evening. She gave the drawing to one of Austin's resident advisors (RA). It was reported that the drawing disturbed the RA so much that she turned it facing the wall. The next day, the picture was found turned around toward the RAs bed.

Another account of the paranormal revolved around a series of frightening incidents in 1896. The college administration became quite alarmed regarding the existence of a banshee in the hall. Screams would emanate from around the elevator and tunnel in the basement, causing the women to panic in the middle of the night. No one, young or old, would venture in the basement late in the evenings.

On May 2, 1979, the *Transcript* promoted a paranormal investigation at the former site of Monnett Hall in which the Psychic Science Institute was invited to investigate ghostly activity. The group had been featured in the *Columbus Dispatch* various times as well as the *Lantern*, Ohio State's newspaper. The group also had been featured on local television programs. During the investigation, two of the group members, who are classified as sensitives, were able to pick up psychic energy that existed before the founding of Delaware, Ohio. They picked up the fact that Indians lived at that location. One of the members commented that wherever Indians had resided, their energies are implanted on that area for years or perhaps for centuries. They were able to feel the presences of many more spirits in the direct vicinity. The group was able to pick up on the name of the son of William Little. A reporter for the *Transcript* told the group only the name of William Little, one of the founders of Delaware, Ohio, and the fact that he was one of the original owners of the limestone quarries. One of the sensitives, who was identified as Kay Frain, public relations director of the group, felt the presences of John Little and William Drake. They did not recognize the names of these men and did not realize their significance to the area until they conducted research at the Delaware County Historical Society. At the society, they were able to learn that John Little was the son of William Little. John Little was a roommate of Rutherford B. Hayes while attending Keynon College. Later, John Little became a physician. Through further research, the group was able to find that William Drake was an Indian fighter who came to Delaware in 1810.

As noted before, spirits walk from the northwest neighborhood and congregate at the Monnett Gardens at night. According to Delaware resident Daniel Howard, there would be twenty to twenty-five spirits meeting in the gardens at one time. One of the spirits he mentioned wore a brown derby or bolo hat and a suit. That spirit has been seen walking from the neighborhood and meeting with the other spirits. The man has also been sighted walking around the old haunted county jail, which is located at the intersection of North Franklin Street and East Central Avenue.

It seems as if Daniel was on the level. In the month of July 2007, one of the new public safety officers at Ohio Wesleyan University decided to venture into the gardens while his senior partner conducted an internal check of Sanborn Hall one evening. As soon as the senior officer finished the check, the young officer radioed for assistance. The senior officer ran as fast as he could where the other officer was sitting on a park bench. The

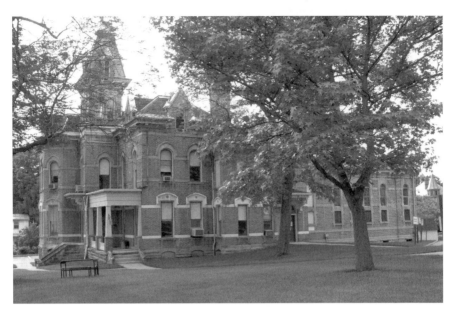

The former sheriff's family residence and county jail. *Courtesy of the author.*

officer had his eyes closed and asked his partner, "Is he gone yet?" Puzzled, the senior officer inquired what was going on. The young officer described a man wearing a brown derby that walked over to where he was and sat down beside him. The man was surrounded by a bright blue aura.

The old Delaware County Jail is a Queen Anne-style built in 1878. It is located at the intersection of North Franklin Street and East Central Avenue. Today, it is no longer in use. The jail was also the residence of Sheriff Rutherford and his family. The wife of the sheriff would cook the meals for the prisoners at the jail. The family resided in the front section of the building and the inmates were placed in the rear of the complex.

People driving by the jail have witnessed an elderly woman standing on the front porch. She turns around and walks through the closed doors to the former residence. Some say that the woman is the wife of Sheriff Rutherford. Every year, the annual ghost walk tour, which is sponsored by the Delaware Northwest Neighborhood Association, goes through the confines of the haunted jail and former residence of the Rutherford family. The building was placed on the Register of Historic Places in 1990. It wasn't too long after this sighting when one of Delaware's residents, who was driving to work on South Henry Street around 6:30 a.m., noticed a gang of prisoners dressed in early period inmate clothes with an armed

deputy walking behind the Selby Football Stadium. The prisoners possessed instruments in their hands that were used to cut down high weeds. The driver pulled over and watched them for several minutes before they faded away in the fog.

Phantom Vehicles

One of the most unusual paranormal incidents occurred at the intersection of North Liberty and West Winter Streets on an evening during the summer of 2008. A historical automobile was seen driving north on Liberty Street and took a left turn on West Winter Street. The automobile was described as a police patrol vehicle. It is not unusual to observe historical vehicles driving on the roads, but this particular squad car was traveling on the street with its wheels six inches to a foot off of the pavement. As soon as the vehicle made its way to the end of the street, it vanished. The witness could not believe her eyes. The attempt to identify the type of vehicle was painstaking, but a photo obtained through the Delaware County Historical Society matches the vehicle observed that night. By the description given,

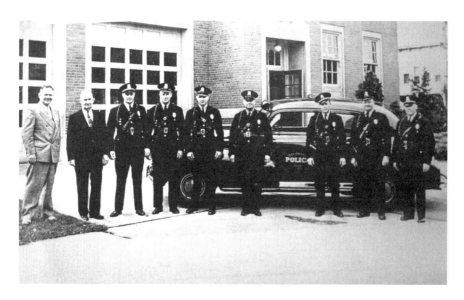

Delaware city police officers with a 1946 Ford police cruiser. This vehicle matches one of the ghost phantom vehicles seen traveling on the streets. *Courtesy of the Delaware County Historical Society.*

it is assumed that the patrol vehicle was a 1946 Ford Model 69A, Super Deluxe four-door sedan, which had been driven at some time by the Delaware Ohio Police Department.

Another sighting of a phantom or ghost vehicle was reported in the month of June 2010. A couple was sitting on the porch of their home on West Winter Street one evening and observed a 1957 Chevy drive down the street. As soon as it drove in front of their home, the vehicle vanished and the couple ran into their home without any hesitation.

The incidents surrounding ghost vehicles do not center just in Delaware, Ohio. In fact, these incidents occur in many parts of the world. In one case, an incident happened as one of the graduating students from Ohio Wesleyan University was making her way back to her home in the state of Connecticut.

In May 2005, one of the Ohio Wesleyan students graduated from the university. After graduation ceremonies, she and her boyfriend were approximately one mile away from their home. They traveled over a single-lane bridge that spanned over a river. As they were halfway over the structure, they encountered a pickup truck going over the speed limit straight toward them. She was about to stop her vehicle and put it into reverse when the truck overtook them. The truck passed right through them. Badly shaken, they got out of the vehicle and looked around for the truck. It was nowhere to be seen. Her boyfriend was videotaping the whole incident and submitted still pictures of the video to their friends.

CHAPTER 13
THE HAUNTED MANSION IN THE NORTHWEST NEIGHBORHOOD DISTRICT

There is a Victorian mansion which is located at 216 North Franklin Street. The family who built it was the Sanborns from Wheeling, West Virginia. The people currently living in the home soon found out that the matriarch of the family still resides there. It is strongly believed that the spirit of Martha Sanborn keeps watch over the home and its occupants every hour of the day and night.

In 1907, at the age of ninety-two, Martha attempted to descend the flight of stairs from the third floor when she lost her balance and plummeted to the marble floor of the foyer on the first floor. As a result, she died instantly. In the area where she met her death, several events had occurred. The residents have sensed a strong and overbearing presence at the foot of the spiral staircase and have encountered feelings of dread and misfortune. In 2002, one of the residents entered the foyer from the outside to find a woman wearing clothing from the Victorian period standing on the first few steps of the staircase and smiling at them.

Martha lived in Ohio County, West Virginia, where she and her family lived on a farm near Wheeling. The Sanborns operated a general store and held title to a large tract of land. The railroad needed the land to build a tunnel and paid the family a fortune to acquire the rights to that land. After Martha's husband passed away, she and her children, Anna, Amelia and Franklin moved to Delaware, Ohio, where Anna and Amelia enrolled at Ohio Wesleyan. While at Ohio Wesleyan, Anna met and became quite smitten with Marshall Clason, a scholar and founder of the Sigma Chi

fraternity on campus. Anna's sister, Amelia, wasted no time to pursue her love interest in V.T. Hills, a Delaware resident from a very prominent family. When the American Civil War began, both men entered the Union army. In 1863, Captain Marshall Clason and Lieutenant V.T. Hills returned to Ohio to marry the sisters and after a wonderful honeymoon, both men returned to their units.

During the war, Lieutenant Hills was promoted to the rank of captain due to his heroics and brilliant methods of strategy on the battlefield against Confederate forces. In one of the battles, he was wounded and, as a result of the injuries he suffered, he became susceptible to illness. It took some time for Hills to recover. Captain Hills came back to Delaware in April 1864 to take command of his father's business. In June 1864, Captain Clason commanded his units in a serious skirmish with Confederate forces on Kennesaw Mountain in Tennessee where he was mortally wounded. Upon hearing of her husband's death, Anna Clason requested that her husband's body be brought back to Delaware for a proper Christian burial. Captain V.T. Hills volunteered his services to retrieve his brother-in-law's body. Hills took what he needed for the trip to the South, including several quarts of whiskey. He used the whiskey to bribe his way onto the battlefield and to enlist several Union soldiers to find Clason's buried body. Once Clason had been located, he was exhumed and placed on a train in the passenger compartment with other soldiers who were either deathly ill with fever and infection or seriously wounded. Captain Hills stayed with him on the train. Once the train reached Chattanooga, Tennessee, a mortician prepared the body for the trip back to Delaware. Hills was present during the entire preparation and during the trip back to Ohio. Anna was very comforted by the way her husband was recovered.

When Hills came back to Delaware to take over this father's business, he began construction of a mansion located at 543 West Lincoln Avenue. At the same time, Martha and Anna were residing at the American House, while their new residence at 216 North Franklin Street was being built. After the Sanborn home was finished, Hills constructed an underground tunnel linking the two mansions so Anna and Martha could visit his family during bad weather conditions. In the 1920s, the tunnel was closed by the city for safety reasons.

The Hills's Victorian mansion later became the home for the Beta Theta fraternity before becoming a nursing home known as the Sunny Vee. In a nursing home, there are times when the residents pass away due to illness

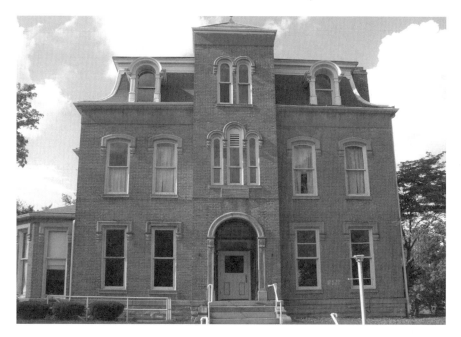

The V.T. Hills Victorian mansion in the haunted northwest neighborhood district of Delaware, Ohio. *Courtesy of the author.*

or natural causes. One of the former employees stated that at times faucets would run in bathrooms and the nurse's call alarms would activate for no reason whatsoever. Sometimes they would feel a presence or two when no one was in the room with them or an employee would be by themselves walking down a hallway and hear the footsteps of someone unseen walking behind them. There were no major incidents inside the mansion to write about. Two years ago, the nursing home closed down.

The Sanborn mansion is the home of the Alpha Chi Chapter of Chi Phi Fraternity. The fraternity moved into the home in 1912. The fraternity is a Greek organization founded on the principles of truth, value and personal integrity. These principles guide the members throughout their lives.

Every year, in the month of October, the fraternity raises money for the Big Brothers and Big Sisters of America organization. Chi Phi's fundraising program is quite unique. They raise money for the organization by building a haunted house within a real haunted Victorian house.

Haunted Tales

Events of the mysterious are not centered only in the area of the foyer by the spiral staircase. The bedroom of Martha Sanborn once consumed most of the second floor of the house. Ever since the fraternity took over the residence, moderate changes were made of the interior. Her bedroom was transformed into three separate accommodations for the brethren. At night, members residing on the floor hear footsteps in the hallway with an occasional knock at their doors. When they leave their rooms to find out who is in the hallway, they see no one. They contribute this to Martha. Sometimes when they are studying, they not only hear footsteps, but they also get a glimpse of a woman wearing a flowing dress walking past their rooms; the woman usually vanishes. On rare occasions they hear footsteps followed by a scream and a sickening thud at the bottom of the stair case.

It had been reported that a procession of footsteps could be heard leading from the living room and into the foyer. Two fraternity brothers went to investigate between 3:30 and 3:45 a.m. As soon as they walked to the foyer, they witnessed several men wearing suits carrying a coffin out of the house. It should be noted that at one time funeral services and wakes were held in homes since funeral parlors were not yet established.

According to John Schaefer, former chapter president Mr. Andrew Harten, one of the fraternity's former housefathers, owned a dog that refused to venture close to the staircase. The dog would walk from the dining area, through the living room and the president's study and out of the double doors in the foyer just to avoid the staircase at all costs. Sometimes, the dog would brace itself by the double doors and bark constantly as it centered its sights on the staircase. John Schaefer remarked that his Labrador retriever did the very same thing on several occasions, but there was one slight difference—John's dog is blind.

The Sanborn Legacy Continues

The Sanborn family used their great wealth to help Ohio Wesleyan University expand into new horizons. The Monnett campus received a boost when a new music building was built. This was made possible through a gift of $53,000 given by Anna Sanborn Clason. Ground was broken in June 1908 for the building. It was to be built as a memorial to Anna's mother, Martha Sanborn Clason, and her brother, Benjamin Franklin Sanborn.

Over time, the music hall became the victim of neglect; steam and water pipes became brittle, through weathering, and leaked through the structure. Insulation around the electrical wiring deteriorated, leaving the wires exposed to the elements, eventually causing shortages in power and developing into a fire hazard. The building shifted often, causing cracks and crevices to develop in the walls and in the foundation and making the interior difficult to heat during the cold wintry months.

In the 1970s, university officials considered razing Sanborn Hall and putting the music department in a new location. A close examination of the hall made officials change their minds.

The amount of $300,000 would be needed to restore it. University planners wanted Sanborn Hall as it was when it was first built in 1909. The recital hall was their main priority. The hall would be climate controlled throughout the year. The three hundred chairs on the main floor and in the balconies were to be reupholstered and its interior would be repainted in antique white and accented in red and gold.

The renovation of the recital hall, now referred as Jemison Auditorium, was placed high on the planner's list to make way for a new organ, valued at $100,000. The organ was coming from Europe and was to be built by a third-generation craftsman, Joseph Kleis from Bonne, Germany. It was a gift to be given by Mr. and Mrs. Leland Shubert in memory of Dr. Rexford Keller, chairman of the Music Department. It would have replaced the pipe organ donated by Anna Sanborn Clason in 1912. But, the Music Department opted to have a much larger organ installed in Gray Chapel.

In 1979, a new addition to Sanborn Hall was dedicated to Dr. Theodore Presser, the founder of the Ohio Wesleyan University Music Department. Presser Hall is an instrumental rehearsal facility.

The entire restoration began in 1980 and work was officially declared completed during a dedication ceremony held on May 8, 1983.

Nightly Unexplained Happenings

You are all alone in an empty building. You begin to feel that you are being watched even though you are the only one in the practice room or walking in the hallways. You begin to hear people talking and cannot determine if you are imagining things due to practicing for hours to get that one section of the musical composition perfected or if there really is an uninvited guest in your midst. Is it the weather or are the noises you hear being caused by people

talking as they walk past the music hall? You look out the windows from the third floor and see no one on the adjacent streets below. You go to the second floor and look out the windows and see no one outside in the lawn between the hall and Austin Manor—and still, the voices persist more than ever. You go down to the first and ground floors and find no reasonable cause to these constant noises. Such was the case of Mr. Paul Devo, an OWU graduate of 1975, who was a part-time student security aide for the OWU Department of Public Safety.

In an e-mail, dated November 6, 2003, at approximately 2:05 pm, he states:

> *I was a music major at Ohio Wesleyan from 1971 until 1975. During the latter two years, I held a part-time campus job. The music department at that time did what they could to place music majors in jobs at Sanborn Hall, mostly in the music library. After a couple of instrument thefts, student security guard positions were established and I was given one of the positions. Our job was to sit in the lobby and collect student ID's when people entered the building, sometimes briefly locking the door to make rounds. At closing time, we could theoretically have returned all ID's and we locked up, made rounds, and turned off lights and closed all the windows. Sanborn Hall was not air conditioned then, with the exception of one or two faculty studios. It we encountered a problem, which was rare, I would call a public safety officer.*
>
> *I usually began on the top floor where the practice rooms are located and finished in the cellar, after which I would leave by the door facing Elizabeth Street. If I had any ID's left, I would take them with me and look for those people. Usually I found people lost in their music and unaware of the time, once or twice I found students trying to hide so they could practice after I closed up. Faculty sometimes worked in their studios late at night; in that case I would leave enough lights on to allow them to exit safely.*
>
> *I still remember one night in the middle of winter during my senior year. Even now, I am getting chills writing about it. The cold weather had caused most people to leave earlier than usual and the building was apparently empty. I had turned off the lights on the third and second floors and was on my way to the first floor when I faintly heard low voices. While the sounds seemed to be coming from the cellar, I checked the third and floors again quickly. Then, I checked the first floor, especially the auditorium. I thought I heard voices again coming from the cellar and walked down the stairs facing Elizabeth Street. I walked around the side of the cellar that was above ground, checking practice rooms and studios, and heard the*

voices more clearly. It sounded like a young man speaking in a low voice and a young woman laughing gaily at whatever he was saying. A section of the cellar on the underground side of the building facing Austin Hall had recently been partitioned for a music library. The thick stone walls and arches were painted white and the most of the walls were covered with bookcases. I always checked the library carefully as the lights were often left on and the stereos with listening turntables were sometimes left running. This was where the voices were coming from. On this night, the lights were off and the library was very cold. This was very unusual in winter, when cold air easily penetrated the building's large old windows and windowless library was a warm refuge. I checked the rooms quickly—the small rooms offered no real hiding places and the few possibilities, under listening tables and the librarian's desk, were checked quickly. I turned off the lights and locked the door. Immediately after locking the door I heard the voices again, much more clearly and definitely coming from somewhere behind the door. A man and woman were conversing in low voices, she was laughing frequently at what he said. I opened the door again and turned the lights on. This time, the library seemed much colder, I felt a definite chill, and the rooms were still empty. Then I heard the voices again, coming from behind the outer wall!

I think I turned the lights out and locked the library door, but I don't remember. I quickly left Sanborn Hall. Once outside, I felt safe again and just stood across the street looking at the building for an unknown amount of time. I was never able to rationalize what I had felt and heard; the building was empty and the underground walls would admit sound-or cold air-from outside.

A senior faculty member later told me that there were tunnels between Sanborn, Monnett and Austin Halls years ago and that a student had murdered his girlfriend in one of the tunnels. I never was able to find any facts about the murder, but I was told by others that the tunnels did exist. Monnett Hall was still standing then. And the Sanborn access to the old tunnels was approximately where the library was located.

Paul's depictions of those events are similar or the same as the events occurring in Sanborn Hall at the present time in the late evenings as the hall is in the process of being locked up. There are other incidents of the unexplained occurring in the music hall at all hours witnessed by students and university staff. Upon hearing such a story, one may wonder if it could happen to them. You have to realize that students presently attending Ohio

Wesleyan will not have heard of such an incident happening to one of the graduate's of the 1970s. But, it has happened again and again in recent times.

In 2004, public safety officers Christopher Wooten and Jason Johnson were in the process of locking up the hall when they decided to inspect the basement where the generator room was located. They already completed turning out the lights on all floors, including the ground floor where the library, student lounge, practice rooms and computer micro lab are located, before heading for the generator room. After the officers finished their very brief inspection, they headed up to the ground floor and found all of the lights had been turned back on. Immediately, they checked all doors leading into the building from the outside and, after a complete and detailed inspection of the premises, it was determined that no one entered the building.

In the fall of 2005, Jessica Walz, Melissa Yinger, Anita Chandresakhar, Jordan "Jody" David-Anton Vasileff and Erika Fox created a film documentary titled *OWU Haunts*, which explored many ghost stories at Ohio Wesleyan. The documentary was conducted as a project in an honors course. The documentary was one of two projects conducted through the Anthropology Department, headed by Professor Mary Howard. One of the aspects explored in the documentary centered on the ghostly folklore of Sanborn Hall. It was then that Melissa learned that a student was practicing their music in one of the rooms on the third floor when suddenly the room got very cold and window flew open. The student ran out of the room and out of the building and did not return until the next day to retrieve the items they left behind. Later, a closed examination of the window determined that it could not have opened up by itself.

Many who walk on the third floor by themselves receive a very unsettling feeling overcoming them. Often students ask others to accompany them to the third floor and stay near as they practice in the rooms. Apparitions have been seen on the third floor and in the lobby of the building, but rarely does this occur, and sometimes a classic melody could be heard coming from the grand piano in the darkened Jemison Auditorium. Again, at the present time, students and staff investigate the whereabouts of the unseen talking and laughing on the ground floor of Sanborn Hall.

December 23, 2008

At approximately 1:30 a.m., on December 23, 2008, two public safety officers had concluded the internal security inspection of Sanborn Hall. They met together in the Jemison Auditorium to rest and situated themselves

on the stage by the grand piano. While sitting on the stage, the senior officer brought up the fact that the building seemed so eerie when he had to walk in the building alone. The officer recounted some of the rumors he had heard regarding the incidents occurring on the third floor and that many of the officers will not walk on that floor by themselves. Officer Jay McCann is quite pragmatic and rational and reassured his senior officer that the events described to him had to have a logical explanation. Up above them, the stage lights started to make noises. Officer McCann contributed these sounds to the expanding of the metal cases surrounding the spotlights when the lights heat up. As the metal cases continued to ping, dust started to fall on the stage below. The officers started to doubt the explanation given as to the cause of the pings. It seemed as if the lights were being hit. Suddenly, a form flew from the structure holding the stage lights and traveled to the upper balcony. The white figure or form vanished. The senior officer motioned to Officer McCann that someone was walking toward them. The sound of footsteps on the wooden floor of the stage was coming increasingly close to them. The officers were the only persons on the stage. In that exact second, a woman's scream could be heard within the auditorium.

They did not hesitate, they did not procrastinate—to run like hell! The senior officer was already out of the auditorium and heading down the stairwell to the ground floor leaving Officer Jay McCann by himself. Officer McCann met the senior officer at the security alarm panel just as the internal security alarm was being activated. Both of them got into their patrol vehicle and sped off the property without looking back.

December 14, 2008

Keith Tankersley and his friend, nicknamed Jobesco, arrived at the university Public Safety Department to inform one of the officers on some of the incidents occurring on the third floor of Sanborn Hall. They were scared half out of their wits.

Keith recalled that around 3:35 p.m., he was in practice room 317 working on a composition for his final grade of the semester and noticed a gentleman stopping by his room. The man looked into the practice room and walked down the hallway. The most unusual thing about this incident was the fact that Keith did not hear the man's footsteps as he made his way toward the choir room; Keith was also uncomfortable because this man resembled a black shadowy figure and he could not make out the person's facial features. At that same time, Jobesco was in four practice rooms down from Keith's

room. Jobesco had the door open. He heard someone walking toward the room and Jobesco thought it was Keith approaching. When Jobesco walked out of the room, the sounds of the footsteps ceased. Once Jobesco reentered his room, the sounds of someone walking down the hall continued. Jobesco and Keith left the building around 6:30 p.m. for dinner and came back around 8 p.m. After arriving at the building, the two students made their way to the music library on the ground floor where they met their friend Brandon. According to Keith, Brandon explained that he was freaked out. Brandon was in room 324 practicing on the piano when the lights to his room began turning themselves off and on for no apparent reason. In addition, Brandon heard someone running around the choir room several times. He went out of the practice room to investigate and saw no one in that direct vicinity. Immediately, Brandon went to the library.

At 10 p.m., Keith and Jobesco went back to the third floor and entered the electronic piano room. There were other students studying for their finals in the room at that time. Suddenly, the lights in the room began to go off and on several times. According to the two men, two of their friends, Chris and John, went out into the hallway to see if anyone was messing with the circuit breakers. No one was around in that area. Still, the lights kept going off and on. The electronic pianos and computer systems in the room were unaffected. When Chris and John went back to the room, the hallway lights began to flicker off and on at the same time. Keith and Jobesco decided to call it a night. Once outside the hall, the lights in the hallway and piano room were no longer going off and on.

Chapter 14
THE STORY OF JOHN EDWIN ROBINSON
THE PIRATE OF DELAWARE

John Edwin Robinson was originally from England. He came to America after his homestead was ravaged by fire and wanted to increase his vast fortune in this new country. In 1825, he arrived in Delaware, Ohio, one evening and lodged in one of the upper rooms of Barber Tavern, which was located on the site of present-day Ohio Wesleyan University. John was not much into socializing with the local populace at the tavern and he was rarely seen. In the morning, John acquired a horse and set off for the southern most regions of Delaware County.

Robinson found a location beside the Scioto River to build his new home. Robinson was a mountain of a man who was able to chop down trees without any trouble and whose strength matched five men. Due to his hired help, his mansion was finished in no time. The hired help noticed Robinson's exquisite furnishings and valuable paintings that soon adorned his entire home. He was known to be a very wealthy man who sometimes slipped a Spanish gold piece or two to pay for his purchases. Indeed, people took notice. Some rumors began to surface that Robinson was in league with pirates and his wealth was a product of plundering. During this time in history, people who resided along the river banks had a reason to be concerned. Piracy on the Ohio and Mississippi Rivers was a problem with Spanish and American governmental authorities from the late 1700s to the early 1800s. The most dangerous pirate known was Samuel Mason, whose activities stretched twenty years. He was several times more dangerous than Blackbeard. Mason began his piracy in eastern Tennessee and continued

until he settled into the Spanish territories of Louisiana. He let his guard down and was apprehended by Spanish authorities who turned him over the Americans. Mason was later hanged for his crimes. Mason's adventures were made into many Hollywood movies in the twentieth century. Robinson's mysterious character attracted many to speculate what kind of person he really was.

Robinson's good looks, muscular build and British accent caused the local women to swoon every time they caught sight of him. Many mothers dreamed of the day that their daughters would be courted by him.

Their dreams were shattered when word got out that a Spanish beauty was seen on his property. She made her residence within the Robinson home. She would be seen near the home walking alone or, at other times, she was seen with Robinson sitting on a stone bench looking down at the valley below. News got out that Robinson used her as a model for his portraits. His skill with the brushes and his knowledge in using the best painting oils gave his images the right to be called masterpieces. Robinson's other endeavors included sculpting wood to produce the finest home furnishings and his skill would gain him international acclaim.

In the fall of 1827, the Spanish mistress was nowhere to be seen on the property. Soon, there was talk that she was badly mistreated and fell victim to Robinson's violent temper. One day, a group of men assembled and went to the mansion demanding to see Robinson. They pounded on the oak double doors for several minutes without a response. They soon left but came back later in the evening. This time, they had a makeshift battering ram that smashed the doors into splinters. Once inside, the men witnessed all of the furnishings were still in the home in perfect order except for the studio where they found several paintings slashed apart and strung throughout the room. Directly ahead of them, hanging over a decorative fire hearth, was a portrait of Robinson dressed in a captain's uniform. To their right was a portrait of the Spanish mistress. A bloody handprint was seen on her portrait and it appeared as if no matter where the men walked throughout the room, the mistress's eyes would follow them. One of the men swore that her eyes started to glow green. An exhaustive search for Robinson and his mistress produced no results. The men went back to the home for one last time. As they entered the studio, they could hear a woman crying.

The men ran out of the home and never looked back. Several local residents searched in the woods near the home to find the mistress. Since it was believed that Robinson hid his gold on the property, the home and grounds were torn apart without any results.

Local residents who have traveled the same paths the mistress took would feel as if they were not alone. Some claim that they had heard moaning and screaming of a woman crying out in pain and despair, while others have claimed to have seen a woman walking the same paths and fading away before their very eyes. People stopped walking near the mansion. Over time, the mansion deteriorated to the point that its foundation sagged and the walls crumbled leaving nothing more than a chimney. No one to this day knows where Robinson and his mistress went, but Delaware County residents believe that the spirit of the Spanish maiden still roams the countryside along the Scioto River.

The Truth Revealed

On May 10, 2010, I met Mr. Louis Robinson Foster, the great-great grandson of John Robinson, who retired from the Columbus, Ohio, Police Department. Louis revealed to me that his grandfather was never the pirate as the legend implies. According to information supplied to me by the Delaware County Historical Society, John Robinson's family were French Huguenots who escaped to England after the assassination of Saint Bartholomew. John Robinson was born in London in 1802. In 1831, he married Elizabeth and from this marriage they six sons and one daughter: Edwin, Alfred John, Reuban W., Arthur Samuel, Edward, Guido and Mary.

John and his family came to America in 1832. He and his family settled in Concord Township in 1834. Robinson came from a family whose talents included artistry and carving and relied on these talents when his hand at farming was interrupted by a severe bout of malaria. His illness weakened him so severely that he abandoned farming and resorted to what he learned in England. Soon, he realized that he could make a prosperous living with his talents. In the mid 1800s, Robinson became well known. He produced portraits for his neighbors, and people from central Ohio came to have their portraits done. News of his work prompted people from the Southern states to request that he paint portraits of their families. The state of Ohio commissioned him to produce carvings for the state Capitol in Columbus, Ohio, which was under construction.

In 1845, the Robinson's home was destroyed by a fire which only left the foundation and chimney standing. He became penniless and had to rely on a friend to advance him with enough funds to build a new home in Scioto Township. Robinson built his business back up from scratch. During his

remaining years, he resumed carving and painting for area businesses and mainly for his family. His life's story captivated many in the state of Ohio and he was featured in the *Portrait Galley of Prominent Persons of Delaware, Ohio*.

In 1994, John Robinson's carvings and paintings were donated to the Delaware County Historical Society and are displayed in the Nash House. It was the wish of Winifred Robinson, the great-granddaughter of John Robinson, that his works are for all of the people to see.

The Nash House is located at 157 East William Street and was donated to the Historical Society in 1994 by Pauline Nash. The house was in the Nash family for sixty-nine years. Most of the Nash family's artifacts are displayed for the public and for educating the young.

CHAPTER 15
THE GHOST OF PERKINS OBSERVATORY

In 1865, Hirum Perkins was appointed to the fraternity of a distinguished class of educators who set the stage for Ohio Wesleyan's outstanding contributions in the sciences. His work in mathematics spanned nearly forty years but his heart was in astronomy. He began to be quite popular on campus. Educators and students alike referred to him as Perky. He was stern as a taskmaster with the sole purpose of wanting his students to share his visions generated by the beauty and harmony of mathematics. His students never forgot his eloquent lectures of the moving bodies in the heavens. No matter how hard he was on his students, they wanted to learn more. Not only was Perky a professor in the sciences, but he was ordained in the ministry. For him, the ministry was only a minor avocation.

Hirum's humble beginnings start in Madison County, Ohio, outside London, Ohio, with him as a young lad raising hogs and pigs. He studied at Ohio Wesleyan and after graduation he became employed as a professor of mathematics. At this time, the American Civil War took a heavy toll on the university. The university had to scale down operations. Hirum temporarily resigned his position with the university to serve his nation. Due to his ninety-five-pound frame, the Union army would not permit him to enlist into the military service, and he went back to his parents' farm to raise livestock for the Union. By raising animals to be used as food, he and his wife, Caroline, became quite wealthy, and as soon as the war ended, they moved back to the home they built at Ohio Wesleyan. His home still stands today as a small living unit (SLU), located at 235 West William Street, used by students who

Professor Hirum Perkins passionately teaching the wonders of the heavenly bodies in the universe. *Courtesy of the Ohio Wesleyan University Historical Collection.*

opt to live outside the confines of a dormitory. Today, his home is referred as the Peace and Justice House. During the 1950s, it was the original Women's House, and in the 1960s, it was referred to as the French House.

The Perkinses began to invest their money to build a student observatory. The observatory was built beside his home, and, in July of 1896, it became operational. It housed a telescope with a lens measuring 9.5 inches in diameter. It had been stated that the heavenly bodies seen through this telescope appeared clearer than the 32-inch telescope housed in Perkins Observatory, which is presently located five miles from the Ohio Wesleyan campus on U.S. Route 23 North.

Originally, the student observatory was rectangular in shape. In 1923, some changes were made to the structure. An office and a classroom were built in addition to a wooden platform circling the dome. Overtime, a new electric clock drive was installed which allowed the telescope to keep pace with the revolution of the earth, as students and faculty observed the heavenly bodies. In time, the telescope was refitted with improved optics.

Perkins Observatory

Hirum envisioned the construction of a world-class facility to be used for research and study. He and his wife made several investments with their wealth. The Perkinses donated $200,000 and the board of trustees donated an additional $100,000. The telescope in the observatory had to be bigger than all others in the United States except for the one-hundred-inch telescope at Mount Wilson. A sixty-inch mirror, rented from Harvard University, was installed in the telescope. Hirum was never able to see his dream completed. At the age of ninety-one, several months before the observatory opened in 1924, he passed away.

In 1931, through an agreement, the observatory was operated by Ohio State University and Ohio Wesleyan; Ohio State University took care of the expenses in operating the facility. In the spring of 1931, the observatory began to publish a quarterly review regarding the research done at the observatory. Later, the review was called the *Telescope*. The management of the observatory continued to publish the *Telescope* until it became the *Sky and Telescope* literary magazine, which is still being read today throughout the United States by professionals and amateur enthusiasts in the area of astronomy.

As technology progressed, a 69-inch mirror was installed that made the telescope the third-largest in the country. The mirror weighed nearly two tons and the lens was 9.5 inches thick. It would be used for thirty years until the 1960s when the telescope was moved to Arizona. Over the years, the usage of the telescope was made difficult during the evenings due to the atmospheric conditions and the elevation where the observatory was built. In addition, the lighting conditions around the facility caused by the expansion of Columbus and Delaware made observing quite difficult. The 69-inch mirror's move was due to Arizona's elevation, climate and darker evenings. This made the collection and analysis of information much better. The mirror had been replaced with a 72-inch one. The 69-inch mirror was brought back to Perkins Observatory for public display in the lower levels of the facility.

In the 1960s, the director of Perkins Observatory, Dr. John D. Kraus, was encouraged by fellow colleagues to add on to the observatory. A radio telescope was built on the east side of the facility. The radio telescope was known as the Big Ear. It covered an area nearly three football fields and it was seventy feet tall on both ends. It became internationally recognized for discovering some of the farthest reaching bodies in our universe. In 1972, the Big Ear set the scientific world upside down through the discovery

Postcard of an aerial view of Perkins Observatory. *Courtesy of the Ohio Wesleyan University Historical Collection.*

of the "WOW! Signal." It was a radio signal that was detected during research conducted by Ohio State University professor Dr. Jerry Ehman on April 15, 1977, through a government grant with SETI (Search for Extra Terrestrial Intelligence). The purpose of the project was to find evidence of life outside the confines of the solar system, and the signal met certain criteria for the existence of life in other galaxies. Upon examination of the computer printout bearing the frequency signal (6EQUJ5), Professor Ehman wrote the word "WOW!" on the side. That is how the signal received its name. Numerous attempts to locate the area where the signal originated have been unsuccessful. In 1997, the radio telescope ceased operation, and, in 1998, it was demolished to make way for the construction of an eighteen-hole golf course located between the Perkins Observatory and the Methodist Seminary.

Ghostly Happenings

There is always a sentence or two regarding Hirum's spirit during the evenings in some of the publications and brochures advertising Perkins Observatory. In the past, students of Ohio State University and Ohio Wesleyan, including

the faculty, have heard moans, creaks and sounds of someone whistling within the confines of the building. Some have contributed these sounds to the settling of the building and wind blowing through the cracks of the brick work and some have contributed these incidents to Hirum.

Little is known regarding the unexplained occurrences in the Perkin Victorian mansion until quite recently. University students residing at the Perkinses' home have noticed people wearing clothing indicative of the 1920s sitting on furniture in the living room and in the hallway on the first floor. The students would stare at the apparitions until they slowly faded away before their eyes. In the middle of the night, the residents would be awakened by sounds of someone running down the hallways. When the residents came out of their rooms to investigate, no one could be found in the hallways or in other areas of the mansion at that hour of the night.

Residents have, on occasion, set their attention to the third level of the home. The only way to enter is to use the overhead ladder that unfolds when one pulls it from the ceiling. At times, personnel from the Buildings and Grounds Department would go to the third floor to conduct maintenance on the upper levels. One of the former house moderators suggested that if anyone would proceed to the third level, the spirits who inhabit it would create chaos on the floors beneath it. He did not elaborate further. The gentleman may be correct. In the spring of 2005, Mr. Christopher Fogle, from Buildings and Grounds, entered the third floor to perform some much needed maintenance. One of the students took a picture of Mr. Fogle as he climbed up the ladder. In the photo, an ectoplasmic mist could be seen coming from the third floor and enveloping him. A few of the residents followed him to the third floor. Several pictures were taken and ghostly orbs could be seen in some of the photographs.

Graduation ceremonies at the university are always scheduled on Mother's Day in the month of May. Two days after graduation, Evanston, Illinois–native Julia Evans was performing some cleaning of the home as part of her duties as house moderator. Julia had to make sure that the house met certain criteria set forth by the university before she was able to close it down for the summer. On one particular evening, she contacted the university's Public Safety Department to report the possibility of an intruder in the home. She reported that someone on the second level was walking in the hallway and moving furniture around. Officers from the Public Safety Department arrived at the house quickly. A complete and thorough search of the house produced no results. The house was kept under constant watch for the entire evening. Julia stated to the officers that she felt as if someone was watching her the entire time she was inside the house.

At 1:30 a.m., on May 18, 2002, one of the officers was on foot patrol in the vicinity of Stuyvesant Hall when he detected the sound of the intrusion alarm within the student observatory. He proceeded to the front entrance and shined his flashlight through the entrance door. He could not see anyone in the lobby. At that same time, he heard someone walk on the wooden catwalk above him. The officer stepped off of the porch to the entrance and shined his flashlight on the catwalk that surrounds the dome of the observatory. No one could be seen. He went back to the front entrance and the sounds of footsteps above resumed. The officer contacted the Delaware, Ohio, Police Department for assistance. Once the officers arrived, a complete search of the observatory was conducted. Nothing was found to indicate that a breaking and entering had occurred. The alarm was reset and everyone left the area.

To investigate the mansion further, an EVP session was conducted in the living room of the mansion in July of 2009. Questions were asked to see whether Caroline, the wife of Hirum Perkins, was still present in the

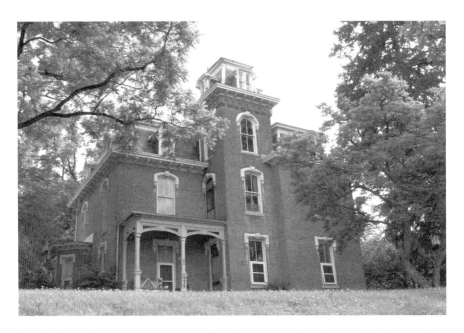

The Perkinses' Victorian mansion where Caroline Perkins still resides in spirit. *Courtesy of the author.*

residence. At one point during the session, a faint response was heard. The results of that session were made public during a house meeting on October 30, 2009. The students were gathered in the living room. I played back the session on my digital recording sound system. During the playback of the recording, a voice out of nowhere stated, "John." It was a voice calling out my name. The recording clearly upset one of the college residents. He came to me explaining that the voice was the same he heard one evening. The gentleman recounted the time he was lying down on a couch talking to one of his friends about contacting the spirits who reside in the house. He especially suggested to his friend that a medium should come to the house. At that exact second, a female voice whispered in his ear, "I would not do that!" He believed that Mrs. Caroline Perkins talked to him that evening.

Caroline Perkins died in the house in the room located on the second floor above the living room. Students in the Peace and Justice House believe that she roams the house and at times makes her presence known.

CHAPTER 16
THE SPIRITS OF THE UNDERGROUND RAILROAD

In many schools throughout the state of Ohio, it is part of the students' curriculum to learn the history of the state of Ohio. One of the subjects discussed in great depth is the Underground Railroad.

Ohio was crucial to the operation of the Underground Railroad system. Over forty thousand slaves made their way to Ohio from other states and through an integral system of secretive routes and hiding places in order to reach Canada. Delaware County, Ohio, was the most successful part of this well-oiled and efficient operation. Nearly four thousand miles of routes were taken to freedom through thirty or more points on the banks of the Ohio River. Once in Ohio, slaves were secretly whisked away to farms, houses with secret rooms and cellars, tunnels, areas in dense woods, forests and swamps under the cover of darkness. They were led by a person known as the Conductor who assisted them on their safe and hazardous journey to Canada. The Underground Railroad reached its height in the mid-1800s just before the Civil War.

Often slave owners would pursue their property into Ohio, either by themselves or by hired bounty hunters, so secrecy was the key to successful flights into freedom. The Ohio citizen instituted crafty ways to transport the slaves even in public places by hiding them in carts and wagons filled with hay, produce and other materials as the wagons made their way to imaginary markets. Other means of transport included the stowing away of slaves in empty boxcars in railway systems and in canal boats, stage coaches and carriages. Sometimes, male slaves would make their way through the

middle of towns dressed as women wearing tailored clothing that hid the face and the parts of their skin.

Even though Ohio was strongly abolitionist, the state legislature made it difficult to harbor slaves. African Americans were required to register with the county where they resided and had to pay a registration fee. The average citizen was not permitted to educate the slave or to protect them. The Fugitive Slave Act of 1850 permitted the capture of slaves by federal marshals and required white people to assist in the capture of slaves when ordered or requested by federal agents. If a slave was captured, they would receive treatment more brutal than they would have if they stayed with their masters. Any white person caught helping a slave would be fined one thousand dollars and incarcerated under harsh conditions.

Due to the fervor of the antislavery movement, states in the North passed ordinances allowing slaves to gain their freedom upon reaching the age of twenty-five. They passed legislation patterned after the Canadian legislature. This permitted the emancipated slave to gain employment and virtually enjoy the same rights and privileges as a white person.

Often, the release from bondage would depend upon the relationship between the owner and slave. The owner could grant freedom as a gesture of gratitude for the slave's long and faithful service or the slave would be granted freedom through a will stipulating their freedom once the owner passes away. These acts are referred to as manumission.

Africa, Ohio, in Delaware County

Africa, Ohio, is located approximately twelve miles east of Delaware, Ohio, on State Route 36. It is named after the Underground Railroad. The unincorporated town of East Orange was renamed Africa due to a disagreement among the congregation of the East Orange Methodist Church established on the east side of Alum Creek in 1828. In 1843, Rev. Samuel Paterson brought in speakers espousing antislavery messages to the church against the wishes of some church members and the bishop. A rift between members of the proslavery and antislavery movements soon developed, which caused the church to split. The antislavery congregation established the Wesleyan Methodist Church near Alum Creek. One of the proslavery advocates publicly chastised the new church and referred to the new congregation as citizens of Africa. The name of East Orange was changed. Other churches involved with the Underground Railroad were

Berlin United Presbyterian, Alum Creek and Otterbein's United Brethren.

The small village of Africa had one saloon, post office and a grocery store. Now, these buildings no longer remain, but some of the homes still exist on Africa Road. The homes once belonged to white families and the manumitted free slaves.

Slaves could not be absolutely safe until they were able to enter Canada. Even staying within the home of the abolitionist could be harrowing and dangerous. During this time, nerves were frayed and tension rose to a fevered pitch. Many ghost stories originate in the homes of those who harbored slaves.

There were instances when the bounty hunters and federal agents received information on the whereabouts of the hidden slaves. Once the slaves were located, all means were taken to extract them from the homes. During the course of these actions, personal property was damaged and people were injured or even killed. Those who harbored the slaves were arrested and imprisoned.

Even if the slaves were not detected, disease and injuries took its toll. The homeowner was in a dilemma: they could not go into town to take the slave to a physician for risk of detection and arrest, so they treated the slave's ailments the best they could. Sometimes, the treatment was not enough and the life of the slave expired. The homeowner was presented with another problem that involved a dead body on their property. The members of the family had to wait until nightfall to take the body out of the home. They had two options: place the body in a wagon and transport it to a wooded area where they could bury it, or they could, under the cover of darkness, bury the body on their property. Often, the homeowner preferred the latter and their land was converted into a graveyard. Since people at that time lived off of the land, a fresh mound of clay or dirt attracted attention right away. The family had to make some excuse for the new development. One answer that had been given by the Burgess family in 1851 was that they were tilling the soil to prepare for a new crop. They tilled an acre of their land to maintain this illusion.

Hauntings

In 1955, the McCregor family owned several acres of farm land in Delaware County. The family became prosperous due to the farming, and life was uneventful. One day, Nancy McCregor was watching her children play in the backyard and noticed the teeter-totter, or seesaw, play set going up and

down by itself. At this same time, her daughter and son were laughing and trying to get on to the play set. The children acted as if they were playing with other children. Nancy could not see any other children in the yard, but she was able to hear them. She also noticed the swings moving rapidly back and forth. There was no wind moving them. Nancy went outside to investigate and, just as she set foot on to the property, she noticed an African American man standing at the edge of their property watching her children. The gentleman was described as a man roughly thirty years of age at approximately six feet in height and wearing bib-overalls that had several tears in the fabric of his clothing. Nancy yelled out for her husband, William. William came out of the house and noticed the man. The man turned around and walked toward a part of the field that had not been tilled. William followed the man into the field and the man vanished into thin air. William also noticed that his feet sank approximately six inches into the ground. These two events started an investigation. William knew about a little of the history pertaining to his property. He contacted the county recorder's office and learned that his property was once involved with the Underground Railroad. He decided to dig up some of the field behind his home. He found several bodies. In time, the total amount of bodies found was twenty-five. It was determined that the bodies were slaves. The slaves were exhumed from the ground and transported elsewhere. They were given proper Christian burials.

CHAPTER 17
A FAMILY'S CONTINUING DILEMMA
THE HAUNTING ON EATON STREET AND BEYOND

Margaret Elizabeth Phelps moved into her new apartment on Eaton Street on July 21, 2008. Her new home was a single-level ranch style, divided into two separate housing units. According to Margaret, strange and eerie events started to occur. Anyone who knows Margaret well understands that she is a very logical, organized, hard-working and pragmatic woman who knows what she wants and will work hard to achieve her goals. She is not apt to create outlandish stories to be noticed or to feel important.

The first evening after moving into her new place was exciting for her. She always dreamed of having a place to herself and to be in charge of her own life. After unpacking her items from boxes and rearranging the furniture just the way she wanted it, Margaret went toward her kitchen and noticed a man leaning up against the doorway watching her. The man was described as a tall man with very dark, olive-colored skin. The male subject had a straw in his mouth. Margaret had first thought that the visitor was the landlord's hired help who was sent to the apartment to fix anything which needed to be mended. The man did not say anything; he just stared at her. Margaret started to rethink her first assumption about the stranger in the kitchen. She asked the person to leave twice. He turned to his right and walked through the wall into the adjoining apartment. Margaret was speechless and stood toward the doorway for several minutes grasping the details of what she just witnessed. She called one of her girlfriends and requested that they stay the night with her in the house. The next evening began the same as the night before. Her visitor made a surprise visit, but this time he left before

he was told to. Minutes after the visit, Margaret's butterfly collection was tossed throughout the room. Two mini-shelves, along with two pictures on the living room wall, were knocked to the floor.

On July 23, Margaret had one of her best friends and her three children over to the house for a visit. During the visit, the children were in the bedroom playing and Margaret and her friend were in the living room. The two of them noticed the bathroom light turning itself on and off; the only way to activate the light was to flip the wall switch. They went to the circuit breaker box to see if something was wrong with the circuits. Everything checked out OK. The same occurred when she was away from the home at work. Margaret would leave the lights off during the day, and, when she returned home, all the lights were found on. Margaret's niece stays with her most of the time and her niece began to notice it, too. Her niece, Maryann, would not venture into the hallway at night without Aunt Margaret by her side. Maryann informed Margaret that she did not like the man who was standing in the hallway at night.

Margaret always had the feeling that she was never alone. She knew about the male spirit, but she had a suspicion that there were two in the home with her. Her fears were verified one Sunday morning when she woke up to see the male entity standing in the doorway of her bedroom. When Margaret started to get out of the bed, her bed started shaking while the male spirit was still standing in the doorway. She heard tapping coming from the left bedpost and then a woman appeared and turned to the male spirit. The woman led him away from the bedroom. Her husband, Stephen, was always the doubting type. He heard the stories but dismissed them at first until one particular evening when they were in the process of retiring for the evening. When Stephen climbed into bed, the tapping resumed and the bed started to shake. Stephen directed his irritation toward the unseen entity at that moment, "Leave us alone, we don't bother you!" Suddenly, everything stopped. The night was peaceful until the next evening when Margaret would feel a cold hand touch her leg at the same time something began to sit beside her. She ran out of the room and went to her mother's house to spend the evening.

Margaret had a brilliant idea to take pictures during the times when the paranormal started to show itself. During these times, pictures were taken, and, at last, the face and upper torso of the male spirit was digitally captured. She e-mailed the photo to her friends and to interested parties. The next evening after the photos were taken of the entity, Margaret requested that the spirit leave her niece alone since her niece had become frightened. At

that moment, the bulb to her niece's night light burned out. Margaret did not have any time to go to the store at that late hour to buy an extra light since she had to be at work in the morning. Margaret returned home the next evening after midnight. She proceeded directly to her niece's room when Margaret remembered that the bulb needed to be replaced. She had electronic candles on the top shelf of her hallway closet. When Margaret went to get them, she found them missing, but at the same time she noticed a light coming out of the room where her niece was. Margaret went into the bedroom to find the candles on the floor by the bed. They had been turned on. The next day she questioned her niece and her husband regarding the candles. Margaret's niece stated that she had no idea that the candles were in the closet and also that she could not reach them due to her height. Stephen denied putting the candles in the bedroom by the bed.

Things in the house started to settle down a little. Margaret and her family began to live a life of normalcy. Margaret and Stephen started to look for a bigger home since the two of them had jobs. One week during house hunting, the occupants in the other half of the duplex moved out and so did the male spirit. For a very short time, they wondered where he went to. They got their answer when a representative from the Columbia Gas Company came to read the gas meter. He knocked on the door with no response, but he did witness the drapes opening and the blinds parting as if someone was inside the apartment. He knocked for several more minutes without a response. The gas company representative went to Margaret's home and inquired why her neighbor would not come to the door to meet with him. Margaret flatly told him that the residents moved out. The landlord verified Margaret's story. Margaret and Stephen believed that the spirit was now occupying the empty apartment. When it was about time to move out of their apartment, events started to occur again. Boxes of the family's belongings were stacked in every corner of the living room. When Margaret and Stephen would come home, they found their belongings taken out of the boxes and placed in other areas of the house. This went on for days until Margaret decided to take her boxes to her mother's residence. After every box had been taken out of the home, Margaret went back inside to check out the place one more time. After the inspection, Margaret was about to head out of the door when she turned around and said, "Bye, Mr. Ghost. It's been great sharing the house with you. Take it easy." She jokingly invited him to come and live with her family in her new home. As soon as she walked out of the door, the door opened up all the way and slammed shut behind her. She believed that all of this was behind her—so she thought.

Bernard Avenue and the Hauntings

Margaret and Stephen moved to Bernard Avenue, which is not too far from their previous residence on Eaton Street. Their home is a two-story house with a basement. On the first floor, the living room connects to the kitchen and adjacent to the kitchen are three other rooms. The upper level contains the bedrooms. Their new residence was once part of a train station. The railroad tracks that intersect Liberty, Franklin, Washington and Sandusky Streets has been cemented over by the city of Delaware, Ohio, to make way for a bike path that extends from the downtown area and over the U.S. Route 23 highway. After the train station was closed down, it was separated into three distinct residences.

Next to Margaret's residence is a home rented by one of her fellow co-workers. Margaret was led to her friend's basement one day and her co-worker, Charlene, showed Margaret a tunnel that was used during the time of the Civil War to hide slaves in the days of the Underground Railroad. Part of the tunnel extends to a certain point where it had caved in during the construction of the street and the separation of the living units. Charlene stated that she will not go toward the tunnel by herself. According to Charlene, she was bringing some of her personal items to store in the basement and was confronted by a shadowy black figure in the entrance of the tunnel. The figure ran from her and passed through a wall adjacent to the entrance of the tunnel.

It was in the month of July 2010 when Margaret received word from her niece that she was hearing a little girl talking to someone in the new residence. At first, Margaret and Stephen dismissed the story. Two days later, Margaret began hearing someone running up the stairs from the living room to the bedrooms. Startled, Margaret went out of her bedroom to investigate and could not find anyone on the stairs, but she began to hear a man and a woman in the home talking. She went into the living room in an attempt to locate the couple. Her search produced no results. Margaret and Stephen began to believe that spirits inhabit their home. The spirits are not malicious in nature. It is speculated that the hauntings are both residual and intelligent at the same time. Could these incidents be the reenactments of events of the past or are the spirits the slaves of the Underground Railroad? It is assumed that tunnels used to hide the slaves extend to other areas into the downtown section of Delaware, Ohio. It is only a matter of time until this mystery is solved.

Chapter 18
OAK GROVE CEMETERY

One of the most logical places to be haunted is cemeteries. The Oak Grove Cemetery is located at 334 South Sandusky Street in Delaware, Ohio. In encompasses eighty-eight acres. The cemetery was founded in 1851, and the first burial occurred on June 20, 1851. St. Mary's Cemetery adjoins it. The cemeteries are maintained by the Ohio Cemetery Association.

Many emotions are associated with cemeteries and the ghosts are attracted to this. Some spirits may not accept the fact that they are dead. It is only natural that they want to continue with the process of life. They desire attention and when people come to cemeteries, they attempt to be recognized. Some spirits will remain in close proximity to their bodies in the hope that some day they will be able to reenter the dimension of the living.

The dangers associated with hunting for ghosts are that the spirits we encounter may not be the spirits of our loved ones. These spirits revel in the anguish we feel when we have lost our relatives. They may assume the role of the loved one with the desire to assist the family of the deceased and then turn against them. But, there are some spirits of our loved ones who stick around to assist the living. The following are cases which had occurred in the cemetery.

Hauntings

In 1957, Fred McDonald and his fiancée, Ellen Hunter, were driving on Sandusky Street around 9:00 p.m. when the 1941 Pontiac they were traveling

in began to stall. Fred decided to pull over into the Oak Grove Cemetery and let his automobile cool down for a few minutes until he was to examine his engine. The day before, the radiator had sprung a leak, which Fred had patched up, and he also had problems with the car's electrical system. The couple got out of the automobile. Fred stayed with his vehicle and Ellen went into the graveyard to examine some of the gravestones. As ten minutes passed, Ellen noticed a young male begin to desecrate one of the tombstones by painting it with black paint. At the exact second Ellen attempted to stop the young man from he was doing, he was lifted up and thrown over several of the tombstones by unseen hands. Ellen screamed in horror and began to run toward the area where Fred was located. Just as Ellen reached the area where Fred was standing, the Pontiac's lights turned themselves on and the engine started to rev up by itself. Both of them got into the automobile and sped out of the graveyard without any thought.

One afternoon in 1966, Mary and William Haney and their six-year-old daughter, Virginia, were in the cemetery looking for some of their long-lost relatives. In the process of searching, little Virginia got away unnoticed from parents. When she realized that she was lost, she began to cry and call out for her parents. Two minutes went by without finding her parents. An elderly gentleman came to Virginia's aid. He was able to calm Virginia down and wipe away her tears. As soon as Virginia gained her composure, the gentleman told her that he knew exactly where her parents were. He led Virginia twenty yards away from her parents. After Virginia spotted them, she turned around to thank him. He was no where to be seen. Mary and William were relieved to see their daughter. She told her parents what had happened and led them to the spot where she met the gentleman. Mary got quite a shock when turned to her right. You see, Mary was desperately searching for the burial site of her great-grandfather. She found his burial plot two feet away from her. Not all spirits are harmful. In fact, some of them assist the living.

Another incident where a spirit interacted with the living was when Edward Ferguson and his family visited the cemetery on April 20, 1967. Edward liked reading the inscriptions on the tombstones, and he and his family spent an hour or two doing so. He noticed one particular tombstone and headed toward it immediately. A man dressed as an American Revolutionary soldier was standing right beside it. As Edward approached the grave site, the soldier blocked Edward's access to it. Edward became frustrated and, at the same time, began to notice that he could see through some parts of the man's body. Edward took charge of the situation immediately. In a loud voice, he

exclaimed, "Sir, I do request to read the inscription on the tombstone before you, me and my family in honor of your gallant service to this great nation!" The man in the soldier's uniform stood aside, and the family was permitted to approach. The inscription on the grave read: "PVT. John Welch, American Revolutionary Soldier. Born: 1745; Died: 1831. Presented by the Daughters of the American Revolution (D.A.R.)." Edward is a retired military officer in the United States armed forces.

Camp Delaware

Beside the Oak Grove and St. Mary's cemeteries, the Union army established two camps that were located on both sides of the Olentangy River during the American Civil War. The first military encampment was situated on the west side in 1862 where it was composed of white soldiers of the 96th and 121st Regiments of the Ohio Infantry. The east camp was established in 1863 and was composed of African American men who joined the Union army. The African American soldiers were inducted into the 127th Regiment at Camp Delaware.

The Strange and Unexplained

Not all spirits stay within the boundaries of the cemetery. Residents living along its boundaries have encountered the spirits of Union soldiers encroaching upon their property day and night. The hauntings have been residual in nature. The residents would experience the sounds of the troops mounting up on their horses to move out of the fort, commands given by Union military officers to their subordinates and an occasional whiff of odors emanating from the horses and livery stables which were once there. It's reliving history all over again.

On occasion, the residents observe balls of lights floating along the boundary between their property and the cemetery. It is watched in amazement. Sometimes, children have attempted to catch these balls of light without success. The lights move rapidly away from them.

Sometimes a spirit is sighted walking from the cemetery and onto the property of the residents. People have witnessed shadowy figures peek into the windows of their houses. On rare occasions, the residents have heard the doors to the rear entrances of their homes open and close by themselves.

Footsteps have been heard in their living rooms and kitchens, and then followed by the sound of cabinets and drawers opening and closing. To persons sensitive to the supernatural, these incidents can be a burden.

One woman, who is very in tune with the supernatural, resides close to the cemetery. When a spirit enters her home she has to communicate with the spirit and explains to them that they are not welcome in her home. She has gone so far as to smudge sage in and around her house to keep the spirits at bay. Likewise, her family does not like surprise visits from the beyond.

Chapter 19
THE HAUNTS OF THE OHIO HOME CEMETERY

The Ohio Home Cemetery is located on the grounds of the Scioto Village Juvenile Detention Center, ten miles out of Delaware, Ohio, in Rathbone. Before the Civil War, the area was a nationally known resort famous for its sulfur springs.

WHITE SULPHUR SPRINGS RESORT

For nearly thirty years, a sulfur spring resort existed along the Scioto River in the Concord Township of Delaware County, Ohio. The resort began when two men arrived in the area searching for salt. When they dug a well five hundred feet into the ground, they struck water. Since they found no evidence of salt in the region, they left discouraged. In 1842, Nathaniel Hart arrived in the county and realized the potential of using the sulfur spring for financial gain. He bought the land from a local farmer and erected small cottages, gazebos and other structures on the 117 acres of land for a resort later known as the White Sulphur Springs Resort.

The principal spring was housed in one bathhouse on a marble basin. He advertised the land as "blessed by therapeutic waters." People, mostly from the southern regions of the United States, flocked in droves to the resort to partake of the water's healing properties. The resort also contained three other mineral springs named the Magnesia, the Salina Chalybeate and the Chalybeate. Other bathhouses were built to contain thermal and cool spas.

In a very short time, elegant three- to four-story Victorian buildings were erected to provide luxury for its wealthy guests. The land was equipped with horse-riding trails, boats for excursions on the lake, livery stables, bowling alleys and a steam laundry. The resort became a town with a post office and train station. The town was named White Sulphur Station, Ohio. The town existed until 1918.

The Scioto Juvenile Institution and the Haunts of the Ohio Home Cemetery

Due to the advent of the American Civil War, Southerners stopped visiting the resort. In 1869, the state of Ohio bought the property to establish a state reform school for wayward girls between the ages of ten to fifteen who were committed by the juvenile court system for status and felony offenses (truancy, incorrigibility, theft, murder, assault, etc.). In 1872, the school became known as the Girls Industrial Home. Later, the name was changed to the Scioto Village Juvenile Correctional Center. The center is operated and maintained the Department of Youth Services. Now, it serves to maintain young women between the ages of ten to twenty-one who have committed felony offenses. The Department of Youth Services has created programs to meet the behavioral needs of the youthful inmates and has operated educational, correctional and rehabilitation centers to accomplish its goals in providing the offender with better means of living a productive life. Scioto became accredited by the American Correctional Association in 2006.

The correctional center is equipped with a school, gymnasium and swimming pool located on the east end of the facility. The landscape is dotted with several cottages and buildings—Boone, Hunter, Alman, Carver, Jefferson and Davy—used to house the youthful offenders. The facility also has a medical treatment and intake center for those inmates experiencing psychological and drug abuse problems. In the 1990s, the center was changed to accompany male offenders. The Riverview School for Boys, located on Home Road across from Scioto Village Correctional Center, was being phased out.

Throughout the 1980s and 1990s, the old resort buildings, which had been used previously for housing the female offenders, were being torn down. The buildings, deteriorating due to old age, were costly to maintain. Most modern housing or cottages were built to house the inmate population.

Along the banks of the Scioto River on the outer reaches of the institution lies the Ohio Home Cemetery. Girls succumbing to disease and misfortune were buried there. The gravestones were lined up in a semicircular pattern. The pattern is based upon an old belief that the devil and his dominion can easily be seen and has no possible way of ambushing those visiting the graves.

In 1995, only one building from the resort used to house the inmates existed—it was Alman Cottage. Even though it was abandoned, it was reported by inmates and staff members that lights were turning on and off even though the electricity was disconnected. In addition, children could be heard singing from within the structure. In the evenings, a teenager was sighted carrying a candlestick holder with a lighted candle as she made her way from one window to another. These incidents were investigated with no results. The inmates have reported seeing children exiting from the old Alman Cottage and proceeding to the new Alman building where the apparitions would tap on the rectangular windows to the rooms holding the incarcerated. Screams from the inmates could be heard. The girls would alert the juvenile correctional officers of their ghostly visitors.

CHAPTER 20
THE PENNSYLVANIA AVENUE HAUNTING

It seems that those in the spirit world do not let up. Once they have a hold of someone, they stay with them until a successful resolution is reached; either the entities are banished or coexist with the living.

Such is the case with Jacob Samson (name changed) who came to Delaware, Ohio, in 1999. Jacob once lived on North Avenue in Plain City, Ohio. He was practically penniless due to the underhandedness of some of his former co-workers who worked for city of Marysville, Ohio. Once they found out where he worked, they would call and talk to Jacob's new supervisors and soon Jacob would soon be out of a job. This went on for approximately five years and Jacob would have to work three part-time positions just to meet the payments on his bills, rent and other expenses. Physically, Jacob was being worn down, but his mind was sharp. He relied upon the emotion of anger to strengthen his resolve and compel him to continue no matter how hard his life became. Anger gave him his strength.

The apartment complex where he resided was a structure two-and-a-half stories high. It was not the best living accommodation, but it gave him a roof over his head. He learned quickly not to trust most of his fellow neighbors. Most of the tenants had run-ins with the local law enforcement agencies and almost every evening the city police department was called to the complex to settle domestic disputes or to arrest offenders. Some of his fellow tenants believed that Jacob was an outcast since he did not party in the late evenings like the others nor did he deal in illegal substances. At one point, the local chief of police questioned area residents about Jacob. Jacob

was straight as an arrow and did not have a criminal record. Area residents on North Avenue would not supply the police chief any information about him; in other words, they played dumb. The residents knew that Jacob had an advanced degree of education and would make something out of himself in due time. There was another aspect of the building that was widely known—the apartment building was haunted. Many tenants would not venture outside their apartments at particular hours of the night and, if they did, they would take their children with them. Mysterious lights and sounds would emanate from the interior of their residences. Kitchen and bathroom cabinet doors would open and close by themselves and sounds of people walking on the floors would be heard. Some of the tenants reported that they would see shadow persons in the doorways of their bedrooms in the middle of the night. Certain objects would be displaced and reappear in other areas of the apartments. These events occurred when Jacob resided there. Everything came to a climax on the evening of October 30, 1997.

Jacob was baptized on October 19 at his church and was preparing to enter into the ministry. Apparently, this did not sit too well for some on the other side of the spiritual plane. Around 11:30 p.m., Jacob was preparing to retire for the evening. Once in bed, Jacob called out for his cat. His cat always sleeps at the foot of his bed at night. His bedroom window faced the field located in the rear of the complex and the light from the street lamp shown through his window. Jacob saw his cat jump on his bed. Suddenly, the cat began to take the shape from a feline into the form of a person. Whatever it was, it grabbed Jacob. Two other entities soon joined in. A violent struggle ensued for ten straight minutes. During the struggle, two of the entities began to talk between themselves in a language foreign to Jacob. Jacob knew that the languages spoken were not human. After the struggle ended, Jacob could not move the right side of his body for about thirty minutes. Jacob's next-door neighbor came running to his apartment after hearing the commotion. His neighbor informed him that they sighted apparitions running from Jacob's bedroom into their home. The apparitions ran through the wall of the bedroom and into their living room where the entities vanished. Jacob talked with them for about two hours. He was able to find his cat, which was curled up underneath the living room couch. It was shaking like a leaf. The building stood silently for the rest of the evening except when seven of the tenants met in Jacob's apartment discussing the events of the evening. They weren't very surprised from what had occurred. They were seeking answers that evening. Some of them made a decision to ride out the storm, and some were determined to move.

In December 2000, Jacob got his big break. He received a new job and a new residence in Delaware, Ohio. He thought the events he experienced were finally behind him. Jacob was able to move into a ranch-style apartment home. The apartment community was heaven on earth. He was able to walk outside of his new home without any worries whatsoever. The environment was safe.

Three weeks into his new surroundings, Jacob decided to unpack his Christmas decorations. During the unpacking, he sat down on the floor with his cat. She was a beautiful Persian and Siamese mix. She loved jumping in and out of the boxes of ornaments and Christmas lights. Jacob would get frustrated at times untangling the lights, especially when the cat was tangled up in the midst of them. After putting up the lights on the tree, Jacob headed to his bedroom to take a short nap. It was only two minutes after he laid down on the bed when he heard a sound like paper being shredded. Jacob attributed this to the playful sounds of his cat. Then, he heard a long winded rasping sound of a man's voice calling out his name within his bedroom. Jacob realized that one of the spirits followed him all the way from Plain City, Ohio. Nothing else occurred for the rest of the evening. The voice rang out again the following night. Jacob sat up from his bed and stated, "good night," and went back to bed. He made sure that his cat was beside him this time.

Jacob started his first day on his new job and he knew that his future was secure. When he would come home from work, his new neighbors would always ask him if he had a roommate. He always said no. The same question began to become more frequent. He started to inquire why they were asking him these questions. His neighbors would inform him that his television and stereo would come on while he was at his job and that they heard people talking. The noises would come through the thin walls. At one point, his next-door neighbor explained that when she would walk past his home, the living room blinds would part as if someone was peering through them. Jacob requested that the locks to his front door be changed. After the new locks were installed, there were no other incidents. Eventually, the events started to occur again. Jacob realized that he was not alone. He began to accept this fact without fear. At least he knew he had someone watching over his place while he was away.

In May 2001, Jacob received another job offer and took it. The pay was great and he was confident that his financial difficulties would be over in time. He was able to move from his present location to a townhouse complex on Pennsylvania Avenue in 2005. Things were looking up for him.

On September 5, 2005, Jacob decided to take a long stroll throughout the entire city of Delaware, Ohio. He met a traveling Irish priest who was sitting on a park bench outside the entrance of the Sandusky Street Kroger store. Jacob and the priest sat together for the next two hours talking about Delaware and the subject on the paranormal came up. According to the priest, there were too many spirits in the city and he felt very uncomfortable. He advised Jacob to move out if he had the chance. Jacob listened to what the priest had to say. After the two concluded their discussion, Jacob walked back home. Jacob recalled the entire conversation he had with the priest, and Jacob was determined to learn more about the hauntings they discussed. Jacob realized that Delaware was inhabited by the Delaware Indian Nation and that much of the land in the city was deemed sacred by the Indians. He also realized that the city was on top of a foundation made up of limestone and quartz. It is theorized that limestone and quartz is able to retain and trap energy, especially of a spiritual nature. In due time, Jacob would again be facing the supernatural and the unexplained.

In October of 2005, a change in Jacob's work schedule enabled him to devote one weekend to cleaning out his basement. As soon as he set foot on the basement floor, Jacob heard a woman's voice whispering, "I am here if you need me." He paused suddenly and realized that no one was residing on either side of his home. Usually, conversations from his neighbors would carry into the next basement through the cinder walls. Since no one was living on either side of his home, Jacob knew that he had a visitation. He called on Larry Copeland, an intuitive-medium to investigate. Arrangements were made to have Larry come over when Jacob would have a day off from work. When the day came for Larry to come to Jacob's home, Larry went immediately to the basement and sensed the presence of a woman and a man. Larry also sensed that the couple may have owned the land where the townhouses now exist. Jacob relayed other information regarding incidents where his personal items were moved and reappeared again in other areas of the home; kitchen electrical appliances, the television and radio turning themselves on and off; and sounds of someone walking up the stairs to his bedroom at night. In addition, other residents were experiencing similar occurrences in their homes.

A decision was made to contact the Delaware Society for Paranormal Research and Investigation group. In the month of August 2009, the group descended upon Jacob's home. Jacob wanted some concrete answers to these visitations. The group arrived with thousands of dollars' worth of electronic gear to document and record paranormal activity in the home. First, the

group centered their sights on the basement. Contact was made with a woman who cowered in the corner of the north side of the basement. She felt trapped and could not liberate herself from her environment. Jacob left the basement so the group could deal with her dilemma. At times, the group could distinctly hear footsteps coming from the basement to the kitchen area of the home. Voices of a man and a woman were picked up during the EVP recording sessions in the basement. Contact was made with a male entity that made his presence known in the area around Jacob's bedroom. According to the spirit, he did not want to make any contact with Jacob in any shape or form. The female entity did want an audience with Jacob on a more frequent basis. Another male entity toyed with the group. The night after the investigation, Jacob retired for the evening. This time, the spirit who would not have anything to do with Jacob stood outside the bedroom entrance doorway and called out Jacob's name twice.

Since the night that the spirit relented and made contact with Jacob, things had changed. A strong sense of peace can be felt throughout the home. His dearly departed pets have come to appear to him now and then when things are well and when things are not.

Jacob has dismissed the priest's advice to leave Delaware, Ohio. To Jacob, ghosts are not to be feared; they are part of God's grand scheme of things. Ghosts are one of the many wonders that the great spirit has in store for us.

BIBLIOGRAPHY

Alicie, Stephanie. "Strand Theatre Renovates, Keeps Fighting for Audience." *Delaware Gazette*, October, 27, 1988.

Artist-Sculptor: A Collection of Works by John Edwin Robinson. Delaware, OH: Delaware County Historical Society, 2009.

Bear, Jamie. "Ghost Stories to be Told: PS Officer Ciochetty to Write Book on Haunts of OWU." *Transcript*, October 14, 2004.

Big Walnut History. "Because You Asked." Big Walnut History. http://www.bigwalnuthistory.org/Local_History/willis/Willis.htm (accessed April 1, 2006).

Brittle, Gerald. *The Demonologist: The Extraordinary Career of Ed and Lorraine Warren*. Englewood: Cliffs, NJ: Prentice-Hall, Inc. 1980.

Buckingham, Ray E. *Delaware County Then and Now*. Delaware, Ohio: History Book, 1976.

Bullock, Bryan. "A Walk through Delaware's Spooky Past." *Delaware Gazette*. October 19, 2009.

Cartnell, B.E. "Frank Stuyvesant." *Ohio Wesleyan Magazine* (March 7, 1930), 183–184.

College Transcript. "Perkins Astronomical Observatory." June 17, 1896. OWU Online. http://go.owu.edu/~starweb/history.html (accessed January 10, 2005).

Comstock, Paul and Rich Elias. "Last Downtown Theatre in County to End 77 Years Showing Movies." *Delaware Gazette*. December 24, 1993.

Bibliography

Cope, Kathy and Kevin Greenwood. Interview with the author. April 29, 2010.
Davies, Ruth. "The Passing of the Card Catalog: A Lament." *At the Library: The Newsletter of the Friends of Ohio Wesleyan Libraries* (Fall 1994), 1.
"Dedication of Stuyvesant Hall at Commencement." *Ohio Wesleyan Magazine* (July 1931), 246–247.
Delaware Gazette. "Beautiful Strand Theatre Opens Doors to Public," April 11, 1916.
———. "Delaware to Have Big Movie Theatre: Will Be Located in East Half of New York Cash Building." October 22, 1915.
———. "Garden Dedication at Monnett Site," May 18, 1992.
———. "Red Slippers Murder Left a Grisly Trail." November 11, 1999.
Elias, Rich. "Owners Celebrate Strand Renovation." *Delaware Gazette*, January 19, 1996.
Ellis, Wade H. "A Native Ghost." *Ohio Magazine* 4, no. 1 (January 1908), 55–59.
Forgotten Ohio. "White Sulphur Springs." Forgotten Ohio.com. http://www.forgotten.ohio.com/GhostTowns/whitesulphur.html (accessed August 1, 2010).
Haught, Lori. "I Ain't Afraid of No Ghosts!: PS Officer Busts Myths and Reveals Stories of OWU Ghosts." *Transcript*, October 27, 2005.
Hawes, Jane. "Ghost Tales Live On at Ohio Wesleyan." *Columbus Dispatch*, October 31, 1999.
History of Delaware County and Ohio. Chicago: O.L. Baskin, 1880.
HMdb.org. "Delaware County: Anti-Slavery Stronghold: The Underground Railroad." HMdb.org. http://www.hmdb.org/marker.asp?marker=12829 (accessed August 1, 2010).
Howard, Daniel. Interview with the author. September 2008.
Hubbert, Henry Clyde. *Ohio Wesleyan's First Hundred Years*, rev. ed. Hammond, IN: W.B. Conkey, 1991.
Jolly, Rachel. "Skull Returns to Delaware." *Transcript*, October 26, 2006.
Juliano, Dave. "Types of Ghosts." July 23, 2006. *The Shadowlands*. http://theshadowlands.net/ghost/types.htm.
"Klaus Organ Completed." *Ohio Wesleyan Magazine* 46 (September 1980).
Linton, Jeff. "Monnett Ghost Tales Spur Psychic Institute Visit. *Transcript*, May 10, 1979.
Lowenfish, Lee. *Branch Rickey: Baseball's Ferocious Gentleman*. Lincoln: University of Nebraska, 2007.

BIBLIOGRAPHY

Malone, DuVal. "Tower Was Home, Prank Site for Students." *Transcript*, November 7, 1980.

McVey-Jones, Kara. Interview with the author. June 4, 2005.

Moore, Michael. L. "1953 Slaying Gripped the Nation." *Delaware Gazette*, October 20, 2003.

"More Books and More Students Make Slocum Library's Facilities Inadequate." Ohio Wesleyan University. Archives Information. Delaware, Ohio, n.d.

Murchland, Bernard, ed. *Noble Achievements: The History of Ohio Wesleyan University: From 1942 to 1992*. Delaware: Ohio Wesleyan University, 1991.

Ohio Exploration. "Delaware County Hauntings." Ohio Exploration.com. http://www.ohioexploration.com/delawarecounty.html (accessed March 4, 2006).

Ohio Wesleyan University. "Ohio Wesleyan University to Host Award Winning Comedian." OWU News. http://www.owu.edu/news/2007/20071002-martin.html (accessed October 2, 2009).

———. "OWU Drama Center Dedication Slated." News release, October 19, 1972.

Orahood, Judy. "Dewey Book Reclassification Project Continues After 39 Years." LIS Connections (Spring 2005), 1.

OWU Online. "Book Review Section of the Historian." OWU Online. http://go.owu.edu/~brhistor/index.htm (accessed June 7, 2010).

———. "Selby Field." OWU Online. http://bishops.owu.edu/selby.html (accessed June 17, 2010).

Phillips, Earl W. "A Short History of Perkins Observatory." *Electronic Journal of the Astronomical Society of the Atlantic* 3, no. 7 (February 1992).

Polinsky, Lauren. "Monnett Garden Thriving with a Little Help from Friends." *Delaware Gazette*, May 15, 2007.

Portrait Gallery of Prominent Persons of Delaware, Ohio, with Biographical Narratives. Mansfield, OH: Biographical Publishing, 1891.

"Proposal to Renovate Sanborn Hall-The Music Building of Ohio Wesleyan University." Wesleyan University Library Archives, n.d.

"River Pirates." *Perspectives* (Fall 2006). http://perspect.siuc.edu/06_fall/river_pirates.html.

Rose, Mary. "Gray Chapel Wowed Delaware in 1890s." *Delaware Gazette*, October 24, 1992.

Rush, Cynthia. *Money, Madness and Methodism: The Story of Mary Monnett*. Columbus, Ohio: Innovations Resources, 2002.

Bibliography

Schlichting, Kay. "The People Behind the Names: Ohio Wesleyan Buildings, Part II." *At the Library: The Newsletter of the friends of the Ohio Wesleyan Libraries*, Fall 1994.

Sewell, LaShanna. "Ghost Stories Haunt the Residents of Stuyvesant Hall." *Transcript*. November 15, 1994.

Smith, Robin. *Columbus Ghosts II*. Worthington, OH: Emuses Press, 2003.

Thomson, W.D. "Fifty Years Ago: Edwards Gym Was Dedicated." *Delaware Gazette*, February 20, 1956.

Tull, Barbara M. *One Hundred Fifty Years of Excellence: A Pictorial View of Ohio Wesleyan University*. Delaware: Ohio Wesleyan University. 1991.

"University Hall." *College Transcript* 27, no. 2 (June 20, 1893).

Urda, Peter. "Re: Stuy Ghost Story." E-mail to author. January 6, 2004.

———. "Re: Stuy's Haunted Radio." E-mail to author. January 3, 2004.

Vant, Naomi. "Strand Theatre Has Seen Many Changes." *Delaware Gazette*, June 17, 1983.

Walker, Rollin III. "In Memoriam: David S. Gray." *Ohio Wesleyan Quarterly* 4, no. 3 (April 1921), 17–18.

"We Hail From the Hall Called Monnett." *OWU Magazine* 19, no. 3 (January 1942).

Welcome to the Delaware County Historical Society's Nash House. Delaware, OH: Delaware County Historical Society, December 2005.

Wikipedia. "Africa, Ohio." Wikipedia, the free encyclopedia. http://en.wikipedia.org/wiki/Africa_Ohio (accessed August 1, 2010).

———. "Arts Castle." Wikipedia, the free encyclopedia. http://en.wikipedia.org/wiki/The_Arts_Castle (accessed April 14, 2010).

———. "Branch Rickey." Wikipedia, the free encyclopedia. http://en.wikipedia.org/wiki/Branch_Rickey (accessed May 21, 2010).

———. "Delaware (grape)." Wikipedia, the free encyclopedia. http://en.wikipedia.org/wiki/Delaware_grape (accessed May 30, 2010).

———. "Frank B. Willis." Wikipedia, the free encyclopedia. http;//en.wikipedia.org/wiki/Frank_B._Willis (accessed March 22, 2010.

———. "WOW! Signal." Wikipedia—the free encyclopedia. http://en.wikipedia.org/wiki/WOW%21_signal (accessed June 16, 2006).

Woodyard, Chris. *Haunted Ohio III*, fifth ed. Dayton, OH: Kestel Publications, 2007.

Yoakum, Lee. "State Basketball Tournament Was Time for Town to Celebrate." *Delaware Gazette*, March 28, 1988.

ABOUT THE AUTHOR

John Ciochetty has been recognized in the Marquis Who's Who in America and in the Marquis Who's Who in the World for his accomplishments as an educator on the university level, author, military officer, volunteer member of the U.S. Vice President's National Performance Review under the Clinton administration and as a judicial and law enforcement officer in Ohio and West Virginia. He began his writing career as a reporter for his high school newspaper in Belpre, Ohio, and continued as a freelance reporter and feature writer for area newspapers and magazines as he pursued his undergraduate and graduate studies at Marshall University. His first publication, *Nuclear, Biological and Chemical Warfare Defense*, was written during his service with the United States Army Reserves. He published another book, *The Ghosts of Stuyvesant Hall and Beyond*, in 2007. At the present time, Ciochetty resides in Delaware, Ohio, and is employed as an officer for the Department of Public Safety at Ohio Wesleyan University. He resides in a haunted house.

Visit us at
www.historypress.net